With love and thanks to my parents, Kate Buchbinder Korn and Burton Carl Korn, who allowed me to be a French major even though they didn't really understand why I would want to. This is why.

This edition published in 1997 by
Tiger Books International PLC, Twickenham

This book was designed and produced by
Todtri Productions Limited
P.O. Box 572, New York, NY 10116-0572
FAX: (212) 279-1241

Printed and bound in Singapore

ISBN 1-85501-887-X

Picture Credits

The Art Institute of Chicago 7

Bethnal Green Museum, London 29

Fogg Art Museum, Harvard University, Cambridge, Massachusetts 21

Hirshhorn Museum and Sculpture Garden, Smithsonian Institution, Washington, D.C. 12, 55, 82, 88–89, 125

The Metropolitan Museum of Art, New York 23, 26, 79

Musée des Beaux-Arts, Marseilles 74

Musée des Poitiers 102

Musée du Louvre, Paris 17, 38

Musée Rodin, Paris 8, 9, 11, 14–15, 16, 19, 24–25, 32, 34–35, 43, 44, 50, 51, 59, 65, 68, 69, 70, 71, 72, 73, 80, 83, 98–99, 104–05, 106, 111, 112, 114–15, 117, 118, 122, 123

Musée Rodin, Paris/Art Resource, New York 52, 61

The Museum of Modern Art, New York 120–21

National Gallery of Art, Washington, D.C. 31, 90

Philadelphia Museum of Art 76, 85, 92, 93 (left), 100, 103

The Rodin Museum, Philadelphia 5, 6, 13, 18, 20, 22, 27, 28, 30, 33, 36, 37, 39, 40, 42, 46, 47, 48, 53, 54, 56–57, 58, 60, 62, 63, 64, 66–67, 75, 77, 78, 84, 86, 87, 91, 93 (right), 94, 95, 96, 97, 107, 108, 109, 110, 113, 116, 119, 124, 126–27

Author: Irene Korn

Publisher: Robert M. Tod
Editorial Director: Elizabeth Loonan
Book Designer: Mark Weinberg
Senior Editor: Cynthia Sternau
Project Editor: Ann Kirby
Photo Editor: Edward Douglas
Picture Reseachers: Heather Weigel, Laura Wyss
Production Coordinator: Annie Kaufmann
Desktop Associate: Paul Kachur
Typesetting: Command-O

CONTENTS

A MAN OF CONTRASTS

Late-nineteenth-century France was a world in turmoil. Politics, religion, literature, and art fluctuated between the conflicting values of a monarchy and a republic; religious zealots and those who advocated separation of church and state; tradition and innovation. New ideas were rampant. Some of them died before they ever saw the light of day while others enjoyed a brief moment in the sun then quietly faded. Still others would prove to hold an inner luminescence that could weather alternating periods of obscurity, disdain, and veneration. It is to this last category that the works of the sculptor Auguste Rodin (1840–1917) belong.

During his lifetime, Rodin was both loved and hated—barred from the traditional artistic path yet eventually honored with the highest awards from his peers; scorned as a lying hack then revered as a master innovator; simultaneously renounced as revolutionary and courted by the most conservative members of society. The government and other official bodies commissioned important monuments from him and then refused to accept what he produced. When he died, *The Gates of Hell* and *Monument to Balzac*, the two works that had most consumed him, had still not been cast in bronze. Yet *The Thinker* and *The Kiss* had entered the common artistic vocabulary on both sides of the Atlantic.

The response to Rodin's work after his death has endured the same kinds of tumult. Early criticisms were numerous: Rodin had assistants to execute his works rather than completing the entire process himself; he did not limit the number of reproductions of his works; his subjects were too inspired by literature or museum pieces; he was incapable of producing completed sculpture.

Except for the last accusation—an exaggeration but not without foundation—Rodin and his contemporaries would have been shocked by such complaints. Assistants were (and still are) a way of life for many artists of any standing and, unlike paintings, sculpture was *made* to be reproduced. The criticism of his inspiration would probably have been laughable to the man whose early years were dogged with the constant complaint that his works did not represent any noble and recognizable concepts, that they were, in fact, so true to real life as to be ugly and ignoble.

Part of the difficulty in understanding the changes wrought by Rodin's work arises from the original nature of his art. While the Impressionist painters, for example, banded together as a loose group striving to attain a set of principles, Rodin's work as a sculptor was unique. He did not belong to any one movement. He objected to the strict formulas imposed by

The Thinker

1880 (enlarged 1902–04), bronze. Gift of Jules E. Mastbaum, The Rodin Museum, Philadelphia.
The Thinker was originally designed as a focal point for The Gates of Hell—a symbol
of the poet Dante surveying his work. In its incarnation as a separate statue, the sculpture eventually became a monument to "every person," a universal symbol of hope.

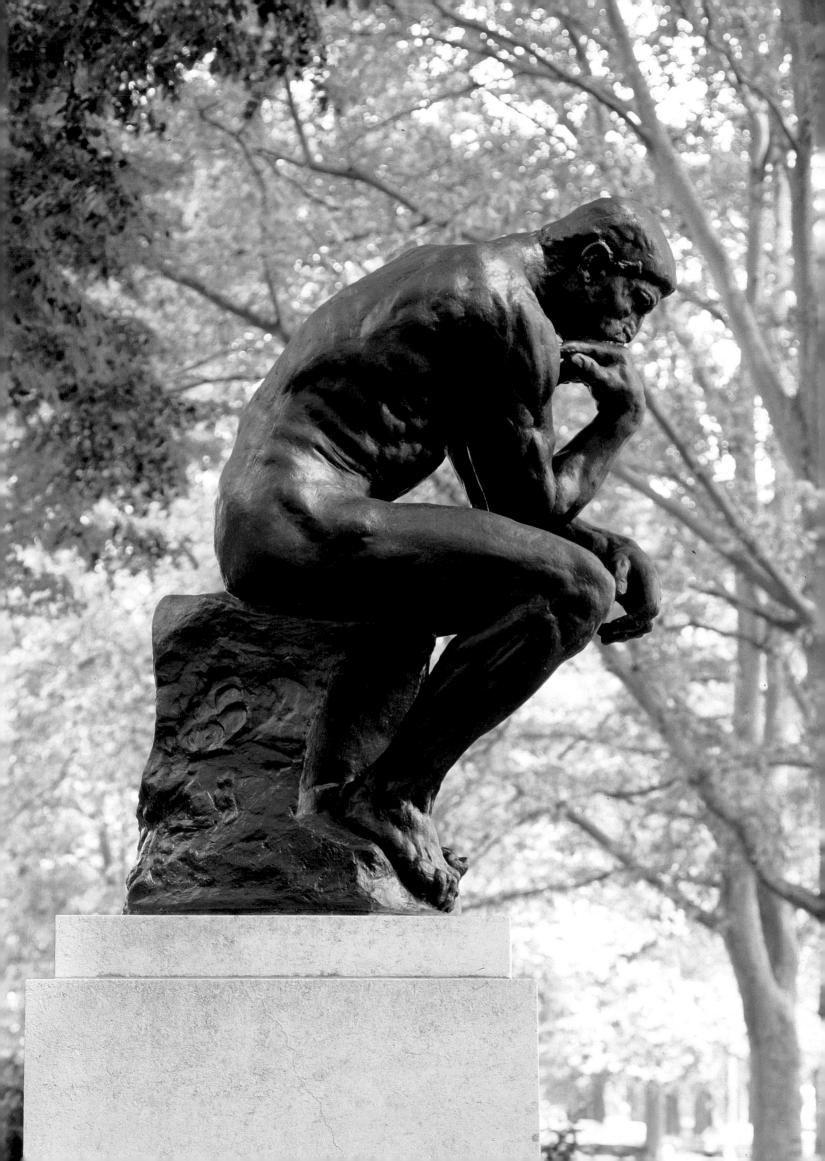

Romanticism, and he would not fully embrace the neutrality of the Impressionists.

There are parallels to Impressionism in Rodin's work, however, especially in his early sculptures, which were faithful reproductions of the human body—so much so that he was accused of having taken a cast for his first major work, *The Age of Bronze*. Also like the Impressionists, light played an important role in his works, as movement is created through the play of light on broken surfaces. Yet the sculpture was not devoid of deeper meaning, and in that respect Rodin was something like the Symbolist artists, although his emphasis on the human body clearly removes the sculptor from the mainstream of that movement.

Rodin often suggested the meaning of a work by his choice of title, but he never chose a title before creating the sculpture. In many instances the sculpture would have a different name at various times. *I Am Beautiful* was called *The Rape*, *Carnal Love*, *The Kiss*, and *The Cat* before Rodin settled on its final name. Many of his titles are also downright misleading, chosen for reasons that only the artist understood. For example, in the early versions of *Death of Adonis*, both figures are women, although in the final version male genitalia had been added to the bottom figure to create a more recognizable Adonis.

In terms of art technique, Rodin's greatest innovation may have been his interaction with his models. He preferred untrained models, and rather than have them stand in a formal position, he would ask them to move naturally around the room so he could observe their movements and see them from all angles. The finished products show the benefits of such a method, displaying an obsessive attention to detail from all sides. In some cases—*The Kiss*, for instance—the work is so thoroughly crafted on all sides that it is impossible to know which view is intended to be the front.

Rodin would always utilize models, and found it im-

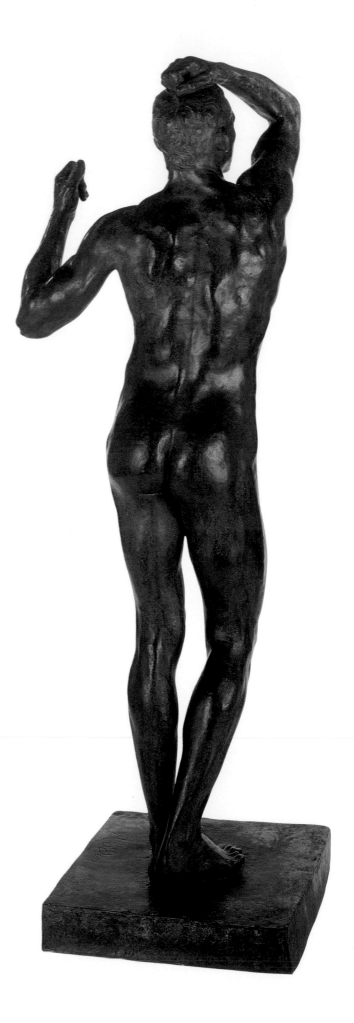

The Age of Bronze

1875–76, bronze. Gift of Jules E. Mastbaum, The Rodin Museum, Philadelphia.
The attention to detail on this work—Rodin's first full-scale figure—earned for the artist a reputation for taking casts from a model, an accusation he vigorously denied and eventually was able to disprove.

possible to create without a live person in front of him. In talks with Paul Gsell that were recorded in the 1911 book *Art: Conversations with Paul Gsell*, Rodin said: "I obey Nature in everything, and I never pretend to command her. My only ambition is to be servilely faithful to her."

Yet in the same interview with Gsell, Rodin commented: "The body always expresses the spirit whose envelope it is." In that spirit, although Rodin respected the physical appearance of the live human form, he did not hesitate to exaggerate or change as necessary to enhance his sculpture. A prime example is *Saint John the Baptist Preaching*: Both of the man's feet are flat on the floor, physically impossible when a person actually walks, yet Rodin has conveyed the sense of movement.

In these respects Rodin was a precursor of many of the later developments in art, although his contributions were ignored for many years after his death. By the 1950s, however, a new kind of thinking was emerging with regard to sculpture. Rodin's works came back into favor, as artists and art critics acknowledged their influence on modern sculpture. In 1955, the Museum of Modern Art in New York finally gave its nod of approval to Rodin with its purchase of *Saint John the Baptist Preaching*. The museum's press release noted that the sculpture "would serve both as a fundamental basis for comparison and point of departure" for modern sculpture. Shortly afterward, the museum acquired *Monument to Balzac* through a donation.

After years of controversy related to *Monument to Balzac*—which threatened at times to blow up into a full-scale political scandal—Rodin told a reporter from *Le Matin* in 1908:

> If truth is doomed to die, my *Balzac* will be destroyed by generations to come. But if truth is eternal, I predict that my statue will gain acceptance. . . . This work, which people laughed at and mocked because they could not destroy it, is the product of my entire life, the mainspring of my aesthetic. From the day I first conceived it, I became a new man.

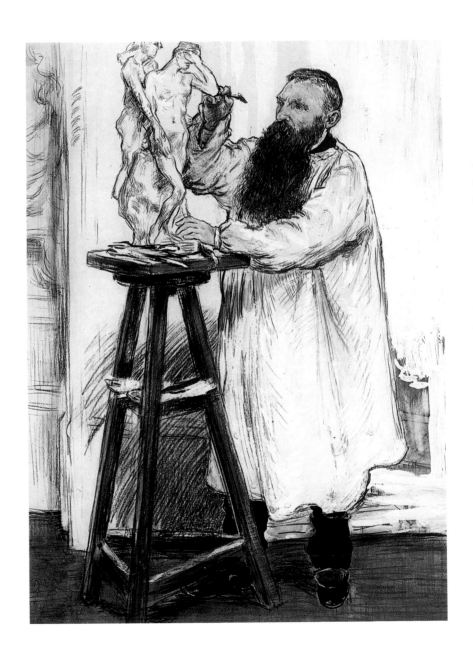

Rodin In His Studio

JEAN-FRANÇOIS RAFFAËLLI; *1900–01, black chalk and watercolor; 23 x 15½ in. (58.2 x 39.6 cm.).*
Olivia Shaler Swann Memorial Fund, 1921.369, The Art Institute of Chicago.
Rodin was legendary for his unusual studio techniques, where he would ask models to move about freely rather than adopt classical and contrived studio poses.

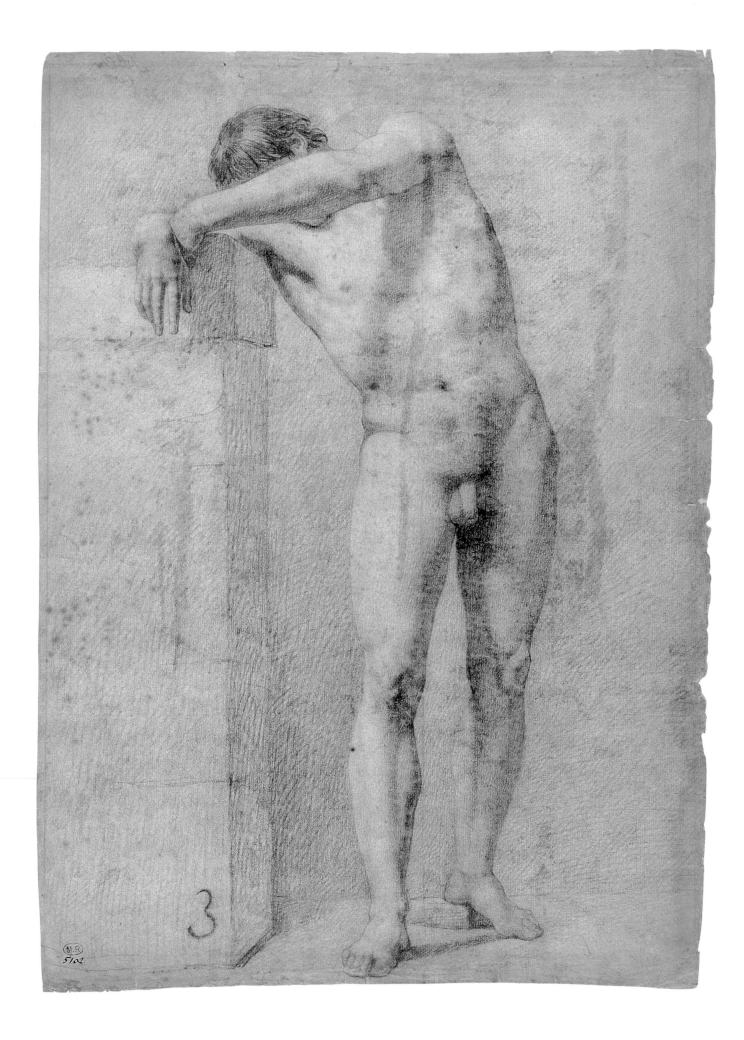

THE EARLY YEARS

How did an impoverished, nearsighted, mediocre student come to be one of the best-known artists of the nineteenth century? Nothing in François-Auguste-René Rodin's childhood presages the genius that would begin to shine when he was in his thirties. He was born in Paris in 1840, the son of Marie and Jean-Baptiste Rodin, a clerk for the police. His early schooling was with the Frères de la Doctrine Chrétienne before spending three years at a boarding school run by his uncle. By all accounts, Rodin did not fare well at either school, having trouble with his reading, writing, and arithmetic. As an adult, Rodin told stories of creating men out of dough while helping his mother bake and copying illustrations whenever he could. When he left the boarding school in 1853, it was to those interests he turned.

The Petite Ecole

Not entirely sure what to do with himself, Rodin enrolled in a free school, Paris's Ecole Spéciale de Dessin et de Mathématiques, commonly known as the "Petite Ecole" to differentiate it from the Ecole des Beaux-Arts, called the "Grande Ecole." The Grande Ecole had been the training ground for great French artists since the seventeenth century; the Petite Ecole had

Study of Nude Model

c. 1857, black carbon pencil drawing; 22⁷/₈ x 16³/₈ in.
(58.1 x 41.5 cm). Musée Rodin, Paris.

Much of Rodin's earliest work has been lost but what remains shows the attention to detail (for which he later would be celebrated) of the human form, especially the musculature of the male body. Rodin drew whatever and whenever he could—male models in classical poses, paintings and sculpture in the Louvre, copies of illustrations in books.

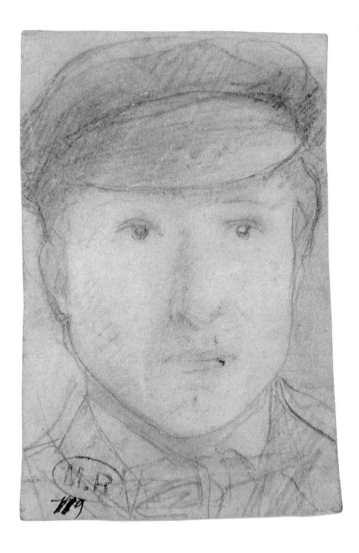

Self-Portrait

n.d., drawing. Musée Rodin, Paris.

Although Rodin learned sculpture during his years at the Petite Ecole, most of his early studies focused on drawing. Because even his earliest works incorporated signs of his later trademarks—including an effort to faithfully reproduce an image without romanticizing or idealizing it—this is likely a fairly accurate representation of the young Rodin.

been founded in 1766 primarily to turn out artisans and craftsmen—commercial artists, jewelers, woodworkers, stucco workers, textile designers, and the like.

By the time Rodin attended the Petite Ecole, it had also taken on the secondary role of providing a path by which students could acquire the background to enter the Grande Ecole, Rodin's eventual goal. Although the primary focus of the Petite Ecole was to teach drawing, mathematics, and composition, Rodin also learned sculpture there, later recalling that the first time he entered the modeling room, he felt as if he were "ascending into heaven."

Clearly not at the level of the Grande Ecole, the Petite Ecole nonetheless attracted a quality of students and teachers who would have a profound effect on Rodin and his eventual career. He became friends at the school with other sculptors who would move on to acquire fine reputations, including Jules Dalou and Léon Fourquet, who became his closest friends. Perhaps influenced by these friends, and possibly by the very atmosphere of the school, Rodin undertook to expand his own education, spending hours in the galleries and museums of Paris, studying both the art itself and learning the history, mythology, and literature that have inspired so much art. Other free time was spent at the Gobelins Factory, a state studio for the production of tapestries, which offered drawing classes with models willing to hold poses for long periods of time.

Another strong influence on Rodin was his teacher, Jean-Baptiste Carpeaux, who would later create one of the most controversial sculptures of the Second Empire—*The Dance*—on the façade of the Paris Opéra. Rodin was also fortunate to study with Horace Lecoq de Boisbaudran, who espoused two ideas that were revolutionary at the time. First, Lecoq encouraged his students to rely on their memory and taught them how to draw an object after it was out of their view, training that Rodin employed throughout his career. Even more importantly, the instructor stressed a natural freedom in the ways his models posed that was in marked contrast to the standard and stylized poses that were then common, believing the goal of art was to "show man acting freely and spontaneously."

In 1913, when an edition of Lecoq's writings was published, Rodin wrote the foreword to the book, stating that he and others in his class "did not truly understand how great was our luck to have fallen into the hands of such a professor. I do now, and most of what I learned from him is still with me."

Despite the benefits of attending the Petite Ecole, Rodin's real goal, like so many other artists of the period, was to be a student at the Grande Ecole. Only students of the Grande Ecole were eligible to compete for the celebrated Prix de Rome. The school was also a fertile mixing ground where students could meet people who would endorse them to show at the Salon—an essential step for artists at the time.

To enter the school, Rodin submitted entries three years in a row; three times he was rejected. None of his sculpture remains from this period, so it is difficult to know exactly why he was not admitted. It seems, though, that he was out-of-step with his contemporaries. His drawings from the time show an emphasis on the real, the natural, even the ugly, during a period when other artists were concentrating on replicating the beauty of classical Greek and Roman art.

Unable to continue his formal education, Rodin began what was to become a twenty-year apprenticeship, working for others at whatever he could. "The necessity of making a living forced me to learn every aspect of my profession," Rodin later said. "I finished bronzes, rough-hewed marble and stone, and finished ornaments and jewelry at a silversmith's. . . . It stood me in good stead." Rather than attend a prestigious school and receive formal training, Rodin would instead learn by doing.

The First Studio

Discouraged by his lack of training and career, Rodin suffered another blow in late 1862 when his beloved sister Maria died only months after entering a convent. At a loss, he followed her lead and briefly joined the Fathers of the Blessed Sacrament, a Catholic religious order, under the name Brother Augustin. While there, Rodin sculpted a bust of Father Pierre-Julien Eymard, the founder of the order. Although the order did not inspire Rodin to a lifelong commitment, the four-month stay apparently revitalized him enough to return to Paris.

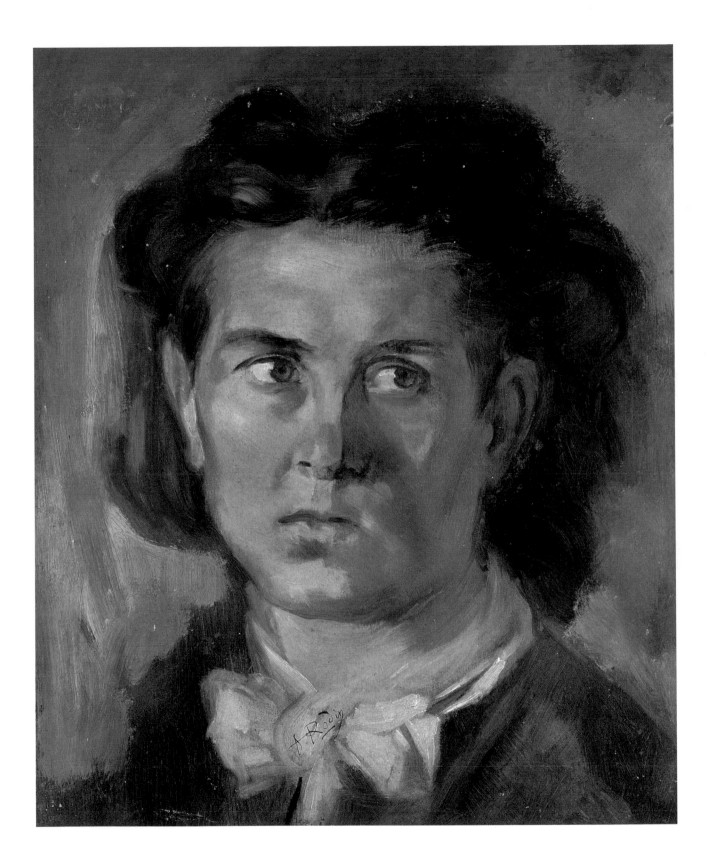

Rose Beuret

1872–73, oil. Musée Rodin, Paris.

For years identified as a portrait of Rodin's mother, this painting is now believed to portray Rose Beuret,
a supposition that holds up when compared to photographs of Beuret. If the work's date is correct, this also
is evidence of its sitter's identity, for it is unlikely that Rodin painted his mother's portrait after her death in 1871.

Now twenty-three years old, Rodin did not move back in with his parents, instead acquiring his first studio. Years later, in interviews with Henri Dujardin-Beaumetz for his 1913 book *Entretiens avec Rodin*, Rodin recalled:

Ah, I shall never forget my first studio!.I spent some hard times there. . . . It seemed to be sufficiently well lit and to provide me with the requisite space to step back and compare my clay with the original—an essential principle which I have always adhered to and never departed from. . . . It was freezing cold, and a brimming well sunk in one corner maintained a penetrating dampness all year round. Even now, I wonder how I stood it!

Unable to support himself with his own art, Rodin continued to work for others, sculpting in his limited spare time. In 1864, while working on caryatids for a local theater, Rodin met Marie-Rose Beuret, a nineteen-year-old seamstress. Years later the writer Vita Sackville-West recorded in her journal that Rodin said Rose had "attached herself to me like an animal."

Although they soon became lovers, Rodin did not introduce Rose to his family until 1866, after the birth of their son, Auguste Beuret. Rodin and Rose had moved in together in 1865, but it would be more than fifty years before the two married, in January 1917, two weeks before Rose's death, and Rodin would never legally recognize his son.

What Rodin considered his most important work of this time, *Bacchante*, modeled after Rose, was destroyed during a move from one studio to another. "I was absolutely scrupulous in drawing the contours,"

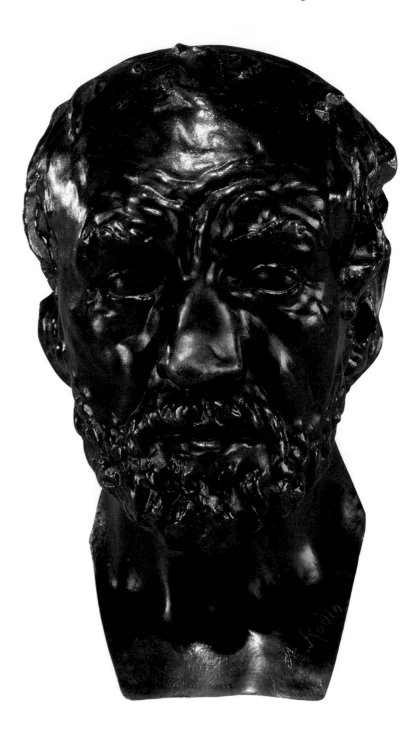

Mask of the Man With the Broken Nose

1863–64, bronze (cast by 1928). Hirshhorn Museum and Sculpture Garden, Smithsonian Institution, Washington, D.C. Although the back of this mask fell off during the freezing cold winter of 1863–64, Rodin submitted the broken work to the Salon of 1865. It was rejected and not exhibited until the Salon of 1872, after he had made changes, including the addition of shoulders and the upper part of the chest.

Rodin told Dujardin-Beaumetz. "I did them ten, fifteen times if necessary; I was never satisfied with one that was merely close."

A local worker nicknamed Bibi provided the inspiration for another important piece, *The Man with the Broken Nose*. Rodin felt the man's face held the classical beauty of ancient Greece and Rome despite a broken nose—or perhaps it was because of it, reminding the artist of the broken statues of antiquity housed in the Louvre. In either case, Rodin rendered the eyes blank in the classical manner while sculpting the rest of the face in a more naturalistic modern style with pockets under the eyes and deep furrows in the forehead.

The winter of 1863–64 was extremely cold and Rodin was unable to keep his stove going. The freezing temperatures caused the bust of Bibi to crack, and the back of the head split and fell off. Nevertheless, Rodin was able to save the front mask portion, which he decided to try to exhibit in the Salon of 1865. Cast in plaster, with a hole in the back, the mask had no chance and was rejected. Still, Rodin later told American sculptor and art critic Truman H. Bartlett that "It was the first good piece of modeling I ever did. . . . I have kept that mask before my mind in everything I have done."

In 1865 Rodin started to work for Albert-Ernest Carrier-Belleuse, a former student of the Petite Ecole and of the sculptor David d'Angers. A fashionable and prolific sculptor, Carrier-Belleuse ran his studio like a factory, employing numerous people to copy his works, which ranged from vases to architectural ornaments, from knickknacks to busts. Soon Rodin was producing works in the style of—and signed with the name of—Carrier-Belleuse. Even if he did not yet have the chance to explore his own artistic talents, Rodin learned two important lessons that would "stand him in good stead" through the years: how to organize a large studio and how to create infinite variations from a single concept.

The Belgian Years

In 1870, the thirty-year-old Rodin was drafted to serve during the Franco-Prussian War. He was discharged before the siege of Paris, ostensibly due to poor eyesight, but after the French surrender in 1871 there was no work to be found for a man of his skills. Carrier-

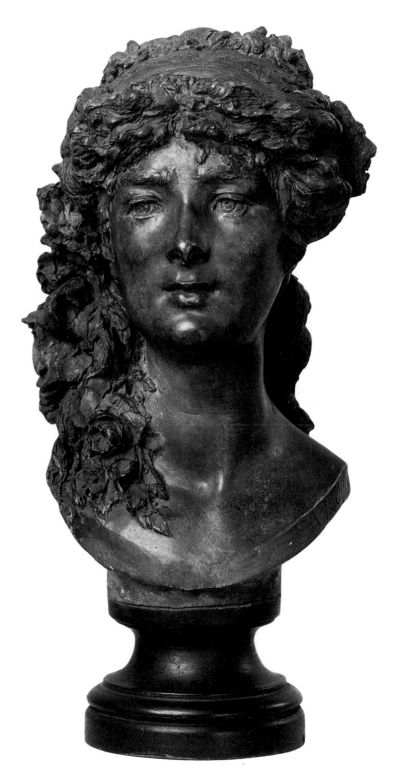

Flora

1865–70, terra cotta, painted brown.

Gift of Jules E. Mastbaum, The Rodin Museum, Philadelphia.

Like many artists of the time, Rodin took inspiration from Greek and Roman mythology. Here, his *Flora*, the goddess of all things flowering, is crowned with hair whose masses resemble the vines she rules.

13

Belleuse had left Paris in the fall of 1870 to work on the new stock exchange in Brussels. In response to Rodin's inquiry, Carrier-Belleuse assured him there would be work for him in Belgium and Rodin joined him there, leaving behind Rose and his son Auguste. Rodin's aunt agreed to care for the child, and Rose moved to Brussels in 1872.

To earn extra money, on his own in the evenings Rodin started to model female busts, in the style of Carrier-Belleuse. Tired of his work being sold with the signature of another, Rodin attempted to sell some works under his own name, but Carrier-Belleuse found out and fired him on the spot. Shortly afterward, Carrier-Belleuse moved back to Paris and his assistant, Antoine Van Rasbourgh, made a deal with Rodin: The two would work together, with Van Rasbourgh signing any pieces sold in Belgium and Rodin getting credit for those sold in France. The arrangement makes it impossible to know for sure what Belgian works signed by Van Rasbourgh might really be attributed to Rodin, although Rodin later claimed credit for some decorative figures on the Palais des Académies and a number of caryatids on the exterior of houses on the Boulevard Anspach. The partnership was dissolved in 1875.

During his six years in Brussels, Rodin discovered a whole new world of art outside of his beloved Paris. When he was not working, he would go to local museums and neighboring cathedrals, which fascinated him, as well as tranquil forests where he could paint in silence and seclusion. His work was exhibited for the first time in Brussels, in 1871, marking his debut as an official sculptor.

By 1875 Rodin had achieved some measure of recognition and returned to his *Man with the Broken Nose*, creating a marble version. Unlike the first, this one was finished in the back and featured a chest and

Drawings from the Italian Trip of 1875

1875, lead pencil, pen, and brown ink on scraps of paper pasted onto cardboard, album assembled in 1930. Musée Rodin, Paris.
Rodin's trip to Italy in 1875 gave him a chance to see the works of masters such as Michelangelo and Raphael and had a profound impact on the artist, confirming ideas about method and contributing to new artistic understandings.

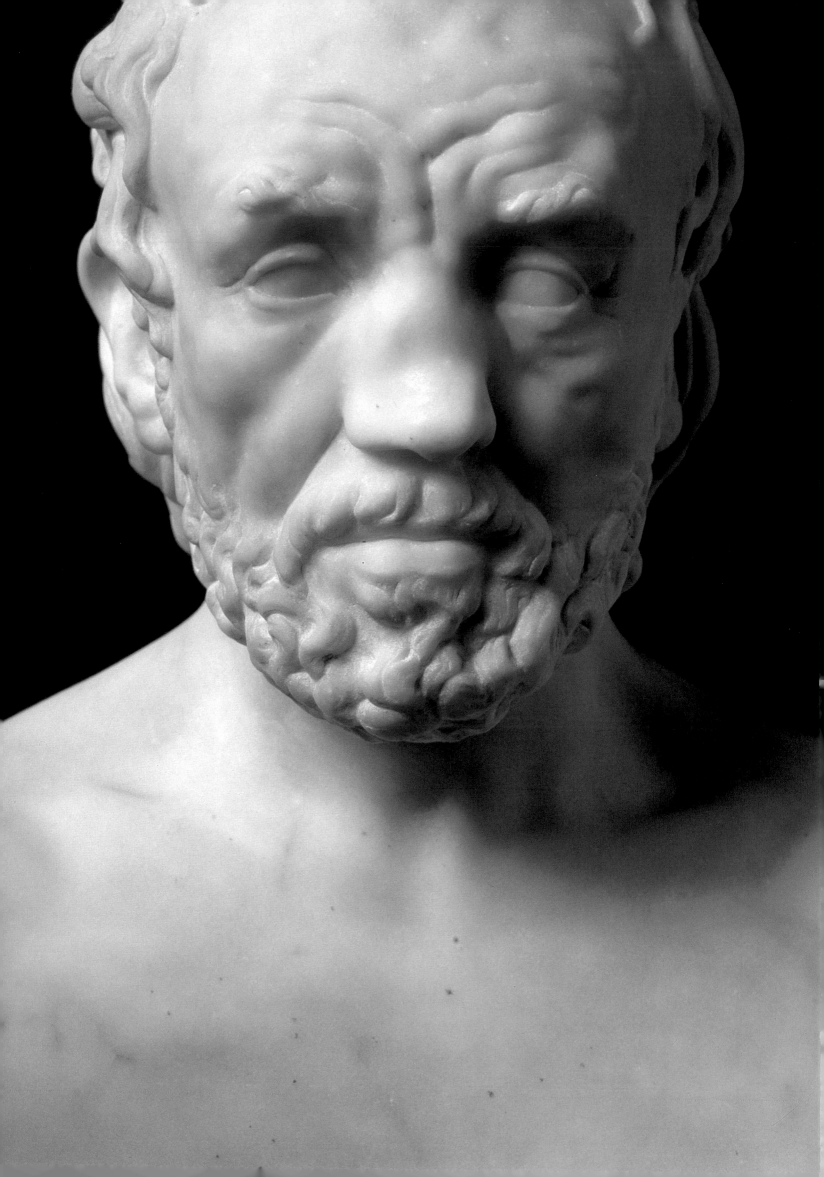

shoulders, set on a base. He again submitted it to the Salon in Paris, and this time it was accepted. From 1871 to 1876, Rodin was able to exhibit busts of men and women, in plaster, terra-cotta, and marble, in shows in Brussels, Antwerp, Ghent, Paris, Vienna, London, and even across the ocean in Philadelphia. Although his work was at last being shown, it was not yet acclaimed.

By 1876, Rodin was determined to fulfill his dream of a trip to Italy to study the masters. Leaving Rose in Brussels, he stopped first in Reims, France, to see the renowned cathedral there, then proceeded to Italy, filling notebooks with his sketches.

The sculptor was especially impressed with the twisting torsos and expressive bodies of Michelangelo. These figures contrasted sharply with the calm and formal balance of the statues from antiquity he was familiar with from his visits to the Louvre. In his conversations with Gsell, Rodin explained: "As my head was full of the Greek models I had studied passionately in the Louvre, I was quite disconcerted by the Michelangelos. At every turn they contradicted the truths I thought I had learned forever."

He might have been confused, but he was also determined. In a letter to Rose in Brussels, Rodin wrote: "You won't be surprised to hear that I have been making a study of Michelangelo ever since I set foot in Florence, and I believe the great magician is beginning to let me in on a few of his secrets."

After two months in Italy, Rodin returned to Belgium, fortified with the desire to create a grand project of his own. He had already started a large figure before he went to Italy and it was to this he returned, anxious to explore with his own hands what he had recently discovered with his eyes. Using a Belgian soldier named Auguste Neyt as a model, Rodin executed his first full-scale figure.

Rodin named the plaster *The Vanquished One* in tribute to the defeated French soldiers of the Franco-Prussian War and showed it at the Cercle Artistique in January 1877. More serious than his previous works, *The Vanquished One* had the bent knees, jutting head, and relatively hollow chest of a Michelangelo figure. Yet it was unique in its realistic portrayal of a man in a seemingly natural position, moving forward yet restrained, holding his spear, his eyes, and mouth half-open in pain.

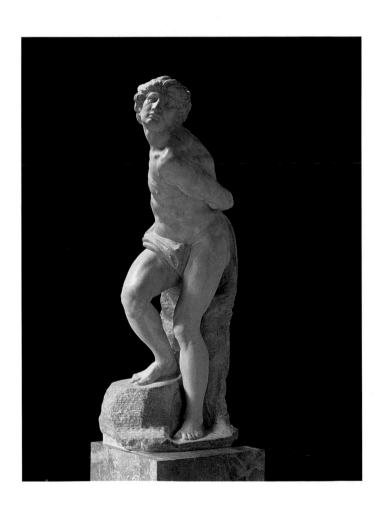

The Man With the Broken Nose

1875, marble. Musée Rodin, Paris.

A transitional piece, this bust retains the blank eyes and noble look of Rodin's early classical busts while moving toward a more naturalistic portrait. The broken nose of the actual model, together with the furrowed brow and tilted head, convey a pathos lacking in Rodin's earlier works.

The Bound Slave

MICHELANGELO BUONARROTI; *1514–16, marble. Musée du Louvre, Paris.*

Even before his trip to Italy in 1875, Rodin was fascinated by the works of Michelangelo. The figure in Rodin's *The Age of Bronze* holds a similar *contrapposto* position to that of the *Slave*, with one leg in front of the other and a bend at the hips; the attention to the musculature and the arm behind the head are other similarities.

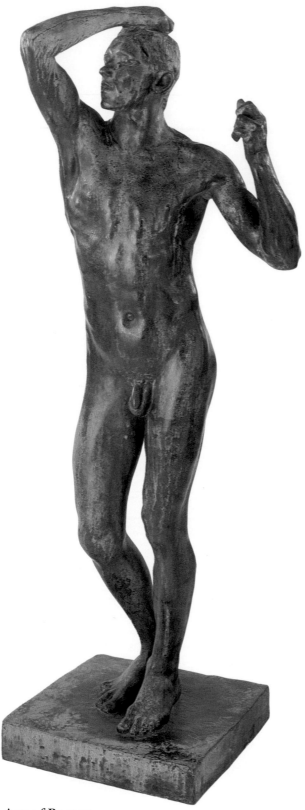

The Age of Bronze

1875–76, bronze. Gift of Jules E. Mastbaum, The Rodin Museum, Philadelphia.
So lifelike that Rodin was accused of casting from the model,
The Age of Bronze started the first of many controversies
surrounding Rodin's work. Although extraordinarily realistic,
when it is compared to the model, Auguste Neyt, some differences
become clear: The body of the sculpture is thinner than Neyt is and
the figure's face is more angular, without the dimple in his round chin.

It was this very realism that was to provoke the first controversy that surrounded Rodin. A journalist who praised the figure in the Belgian newspaper *Etoile belge* commented: "What part casting has in this plaster, we have not examined here." Rodin was furious at the thinly veiled accusation that he had made a cast of a real body rather than sculpting his figure. He countered by writing a letter to the newspaper and offering to introduce his model to an expert to show "how far removed an artistic interpretation must be from a slavish copy."

In the meantime, Rodin made plans to send his figure to the 1877 Salon in Paris. He removed the spear, but that changed the nature of the figure, and *The Vanquished One* no longer seemed an appropriate title. After debating such options as *The Awakening of Humanity* and *Primeval Man*, he settled on naming it *Age of Bronze*.

The accusations of casting resurfaced in Paris, but this time Rodin was determined to fight back. His model, the Belgian soldier Neyt, offered to come to Paris to show himself but was detained by the authorities in Belgium. At his own expense, Rodin had photographs and casts made of Neyt. Finally, he was able to gather the support of a number of contemporary artists to back him, including Alexandre Falguière, Alfred Boucher, Eugène Guillaume, Paul Dubois, and even Carrier-Belleuse, despite their earlier differences.

The other criticism of the figure was its lack of identifiable subject matter. Critics pointed out that the figure was not "noble," that it had no literary, biblical, or mythological origin, and that without the spear it had lost its historical connotation. With one figure, Rodin had moved beyond the constraints of his contemporaries and the controversy surrounding the work raged for years.

Despite the uproar, three years later a bronze version of the *Age of Bronze* was exhibited at the 1880 Salon, won a third-prize metal, and was purchased by the French government to be erected in the Luxembourg Gardens. That same year the figure won a gold medal at the Ghent Exhibition in Belgium. There are no exact numbers, but *Age of Bronze* has since been cast perhaps hundreds of times.

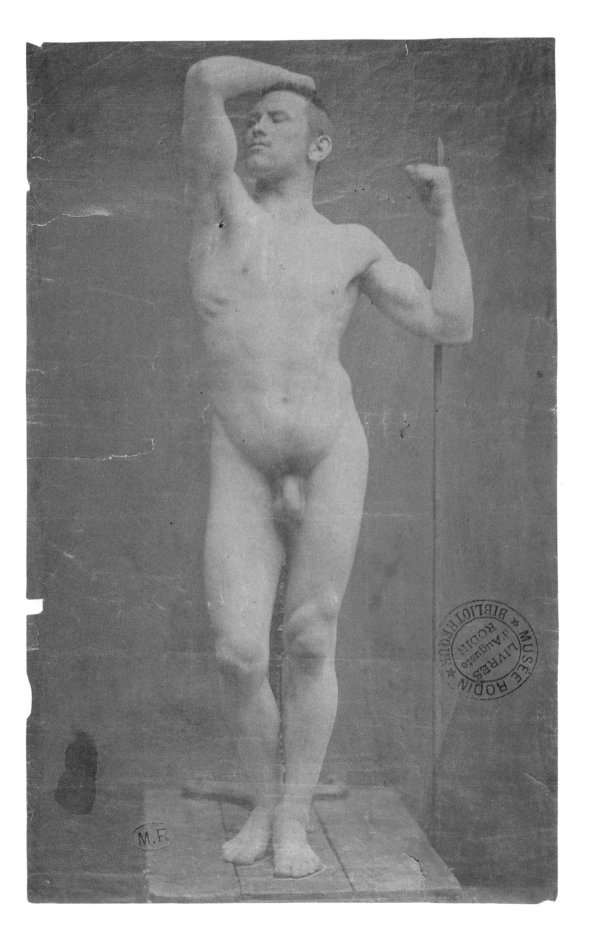

**Auguste Neyt
in the Pose for
*The Age of Bronze***

*1877, photograph (possibly by
Marconi); Musée Rodin, Paris.*
The Belgian soldier
Auguste Neyt re-creates
the pose he held for
Rodin's *The Age of
Bronze*, although during
the actual modeling he
grasped a metal rod to
maintain the position.

St. John the Baptist Preaching (Side View)

1878, bronze. Gift of Jules E. Masthaum, The Rodin Museum, Philadelphia. Rodin described to Dujardin-Beaumetz the scene of his untrained model climbing up on a table to pose: ". . . he planted himself head up, torso straight, at the same time supported on his two legs, opened like a compass. The movement was so right, so determined, and so true that I cried: 'But it's a walking man!'"

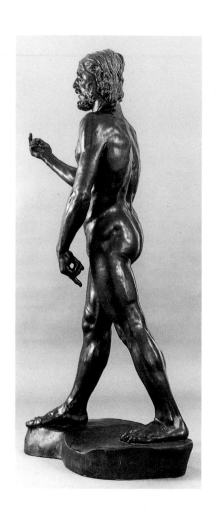

Return to Paris

While in Paris for the Salon of 1877, Rodin made plans to settle again in his home city. After a brief trip back to Brussels to conclude his affairs, Rodin and Rose moved back to Paris, setting up house with their son Auguste and Rodin's father, Jean-Baptiste. Rodin reestablished contact with Carrier-Belleuse, first working freelance for the sculptor and later at the state-owned Sèvres porcelain factory, where Carrier-Belleuse had been made art director.

Poor as ever, Rodin also continued to hire himself out to other sculptors, making statues, busts, jewelry, and cabinets, and occasionally traveling to work in other cities, such as Nice and Strasbourg, when the opportunity presented itself. In vain, the artist tried to establish his own career, entering competitions for the coveted public monuments which were springing up as France celebrated the Third Republic, the government's new incarnation. After the expense of both time and money to develop works for submission, Rodin again and again found only dismissal and discouragement.

In the meantime, he continued to defend his *Age of Bronze* and set about sculpting a new figure. In response to the accusations of casting, Rodin made this new figure larger than life, working with individual pieces—limbs, torso, head, and hands—that he later put together to form a single cohesive body. Rodin later told Dujardin-Beaumetz that the subject matter was suggested to him by the model himself, an Italian peasant named Pignatelli: "I thought immediately of Saint John the Baptist; that is a man of nature, a visionary, a believer, a forerunner come to proclaim one greater than himself."

Besides its large size, *Saint John the Baptist Preaching* was unusual in that the figure successfully conveyed the sense of movement—a feeling that the man was captured in the process of walking—when in fact both of the feet were firmly planted on the ground. A common convention at the time was to tell a model to stand on one foot as though he were walking in order to give the sense of motion; Rodin achieved this same motion in a new and wholly original way.

He did, however, succumb to convention by giving this new figure a clear identity, Saint John the Baptist, a relatively common subject at the time. Years later, around the turn of the century, Rodin pieced together a similar figure at twice the size of life—but without the arms or the head. It is unclear whether this *Walking Man*, as it was dubbed, had originally been a study for *Saint John the Baptist Preaching* or a result of it. In either case, with this torso and legs, Rodin was able finally to forego the sculpture's association with a particular identity and focus solely on the figure's movement.

Saint John the Baptist Preaching was shown in plaster at the Salon of 1880, along with the bronze version of *Age of Bronze*, finally acknowledged as an original piece. No accusations of casting were made. Rodin's professional career had begun.

St. John the Baptist Preaching

1880, pen and ink; 12¾ x 8¾ in. (32.3 x 22.2 cm). Bequest of Grenville L. Winthrop, Fogg Art Museum, Harvard University, Cambridge, Massachusetts. Rodin had initially intended to provide his saint with an identifying cross, as can be seen sketched lightly in this drawing, made after the sculpture. Like the spear in *The Age of Bronze*, though, Rodin removed it because of its interference with the lines of the figure itself.

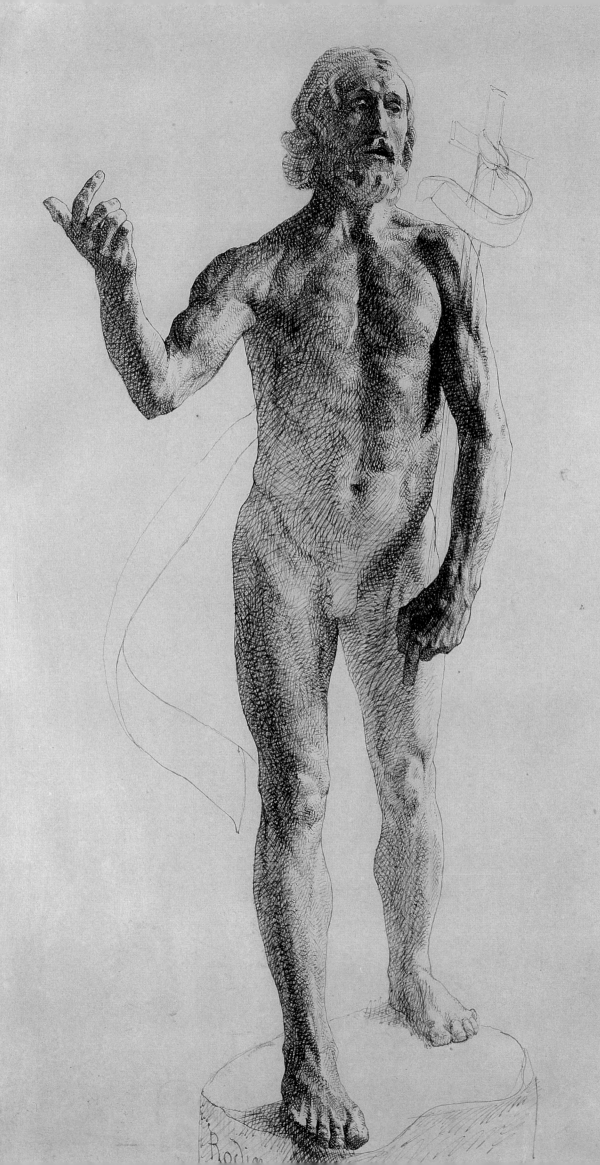

Salon de 1880

A. Rodin

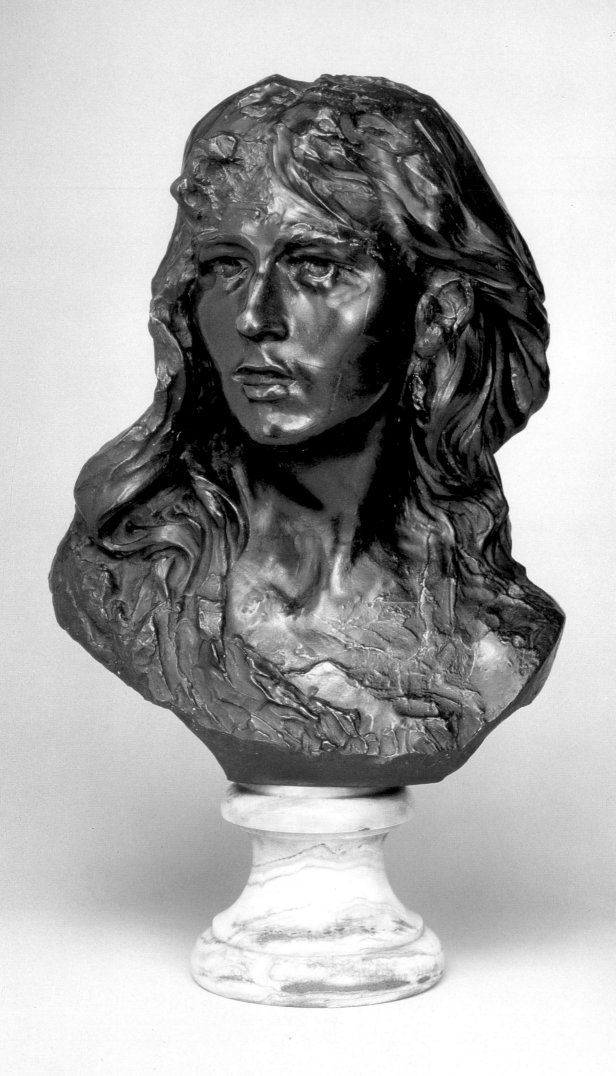

The Walking Man

1877–78, assembled 1900, bronze.
The Metropolitan Museum of Art, New York.
While working on *St. John the Baptist*
Preaching, Rodin kept the limbs and
head separated from the torso so he
could experiment with their positions.
When he connected torso and legs for
this headless version almost twenty-
five years later, the sculptor made
no attempt to conceal the connec-
tions or to match the proportions.

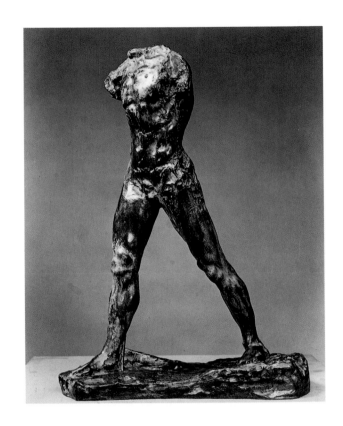

Mignon

1867–68, bronze. Gift of Jules E. Mastbaum, The Rodin Museum, Philadelphia.
French for "darling" or "dear," Mignon may have been
Rodin's pet name for Rose Beuret, generally recognized as the
model for this portrait bust. Without the decorative touches
or romanticized visions of Rodin's other busts of women
from this time, Beuret's intense personality shines through.

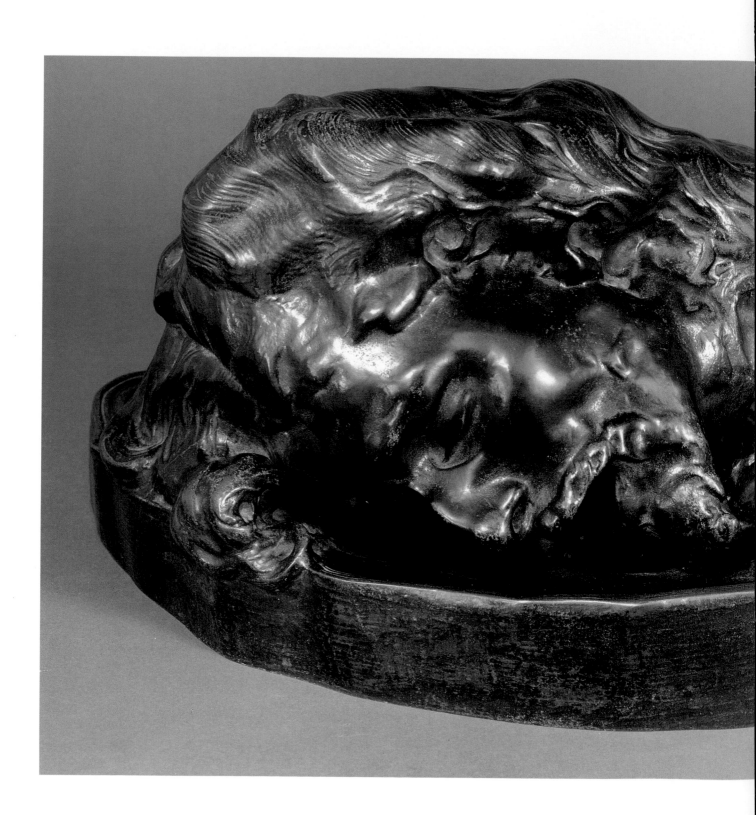

**Head of St. John the
Baptist on a Platter**

1887, bronze. Musée Rodin, Paris.
Almost a decade after he executed
Saint John the Baptist Preaching (1878),
Rodin returned to the theme, but at a
later point in the saint's life—just after
John has been beheaded at the request of
Salome. Here, Saint John rests apparently
at peace, his closed eyes and open
mouth belying the horror of his murder.

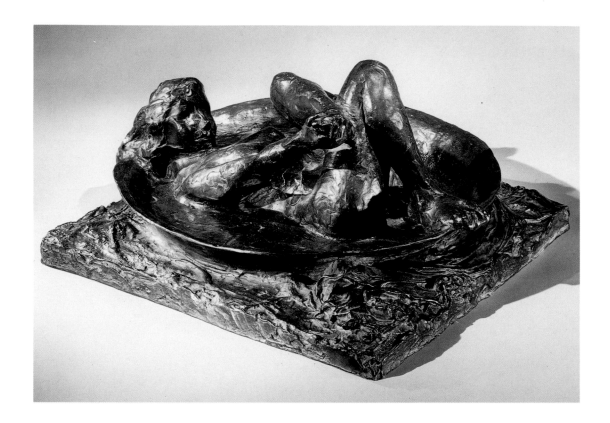

The Tub

EDGAR DEGAS; *Cast from series A in 1920 by Hebrand after Degas' death, bronze. Bequest of Mrs. H. O. Havemeyer, 1929. The H. O. Havemeyer Collection (29.100.419), The Metropolitan Museum of Art, New York.* Besides Rodin, Degas was one of the few artists of the era who experimented with capturing the natural movements of the body, although only one of his sculptures was cast during his lifetime. Degas, again like Rodin, also employed innovative techniques for his bases; here, for example, the viewer has to look down into the tub, much as the artist himself would have.

Alphonse Legros

1881–82, bronze. Gift of Jules E. Mastbaum, The Rodin Museum, Philadelphia.
In 1881 Rodin went to England to visit the artist Alphonse Legros,
another former Petite Ecole student. Legros introduced him to
important men who later became instrumental to Rodin's career.
Unlike some of Rodin's sitters, Legros was pleased with his bust and wrote
to Rodin, stating, "It's wonderful! Really effective, everyone admires it."

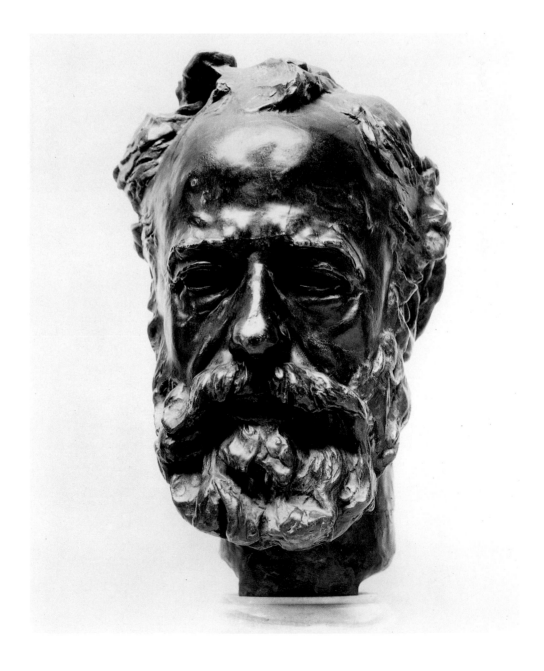

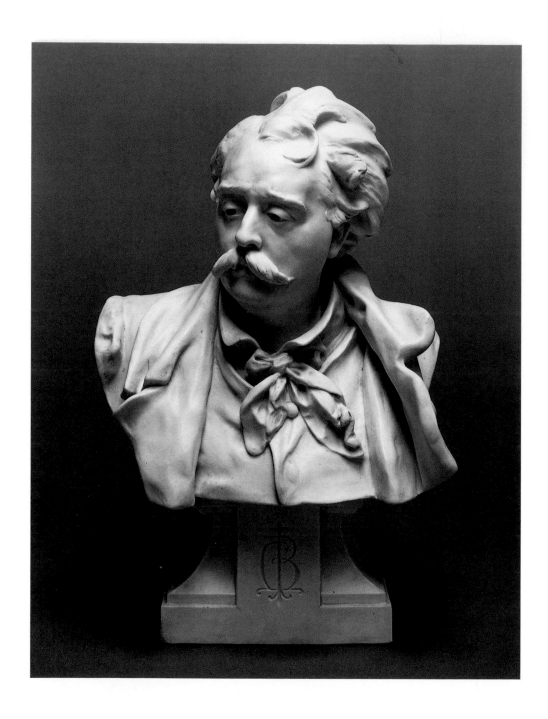

Albert-Ernest Carrier-Belleuse

1882 (executed 1907), biscuit de Sèvres. Gift of Jules E. Mastbaum, The Rodin Museum, Philadelphia.
Rodin worked for Carrier-Belleuse—one of the most prolific and fashionable
sculptors of the Second Empire—off and on from 1864 to 1882, including freelance
work at the Sèvres porcelain factory, where Carrier-Belleuse was art director.
Carrier-Belleuse was responsible for reviving the art of sculpture done in *biscuit*.

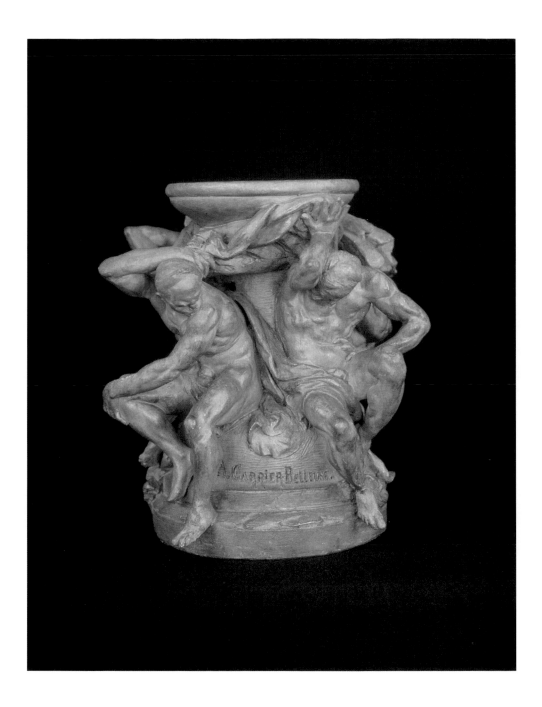

Vase of the Titans

Signed by A. Carrier-Belleuse, attributed to Rodin c. 1876, porcelain. Bethnal Green Museum, London.
Although signed by Carrier-Belleuse, this vase has long been attributed to Rodin
because of the strongly developed musculature and twisted poses of the figures.
The dating has been problematic, though—it was most likely created in 1876 or
1877, after Rodin's trip to Italy but while he was as yet working for Carrier-Belleuse.

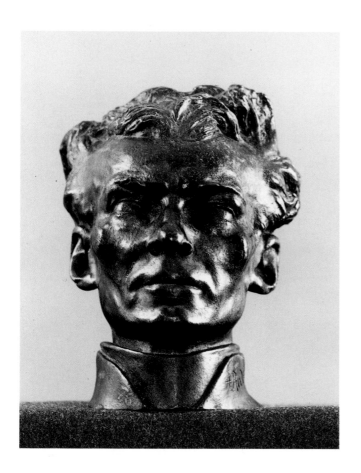

Father Pierre-Julien Eymard

1863, bronze. Gift of Jules E. Mastbaum,
The Rodin Museum, Philadelphia.
This early portrait bust shows the
influence of the classic sculptor David
d'Angers on Rodin, especially in the
taut facial surfaces and blank eyes.
The American sculptor Truman Bartlett
reported that Father Eymard was unhappy
with the bust because he thought Rodin
had made the hair on the sides of his
head look like the "horns of the devil."

Bust of a Smiling Woman

1875, terra cotta. National Gallery of Art, Washington, D.C.
In this rare example, the lips of the sculptor's bust
curve up in a smile. Rodin's figures of both women
and men, even in his later portrait busts, almost never
smile. The artist himself never smiled for a picture.

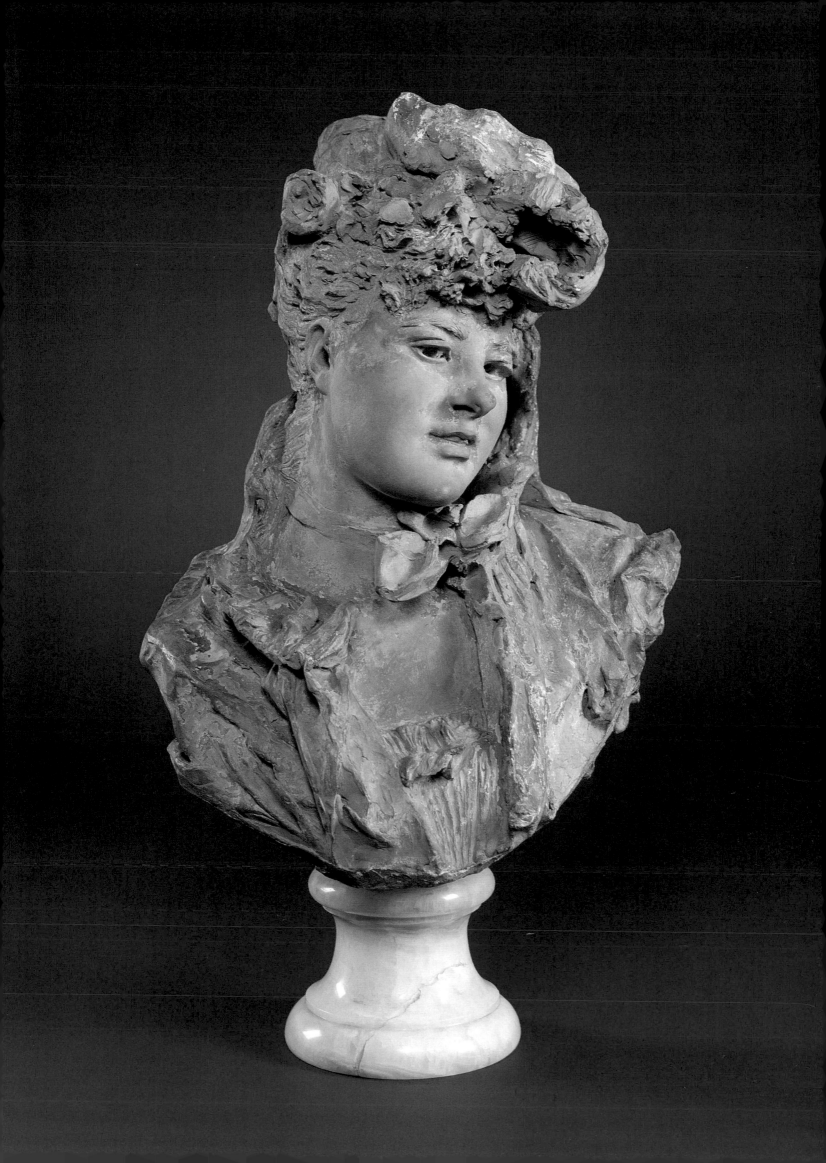

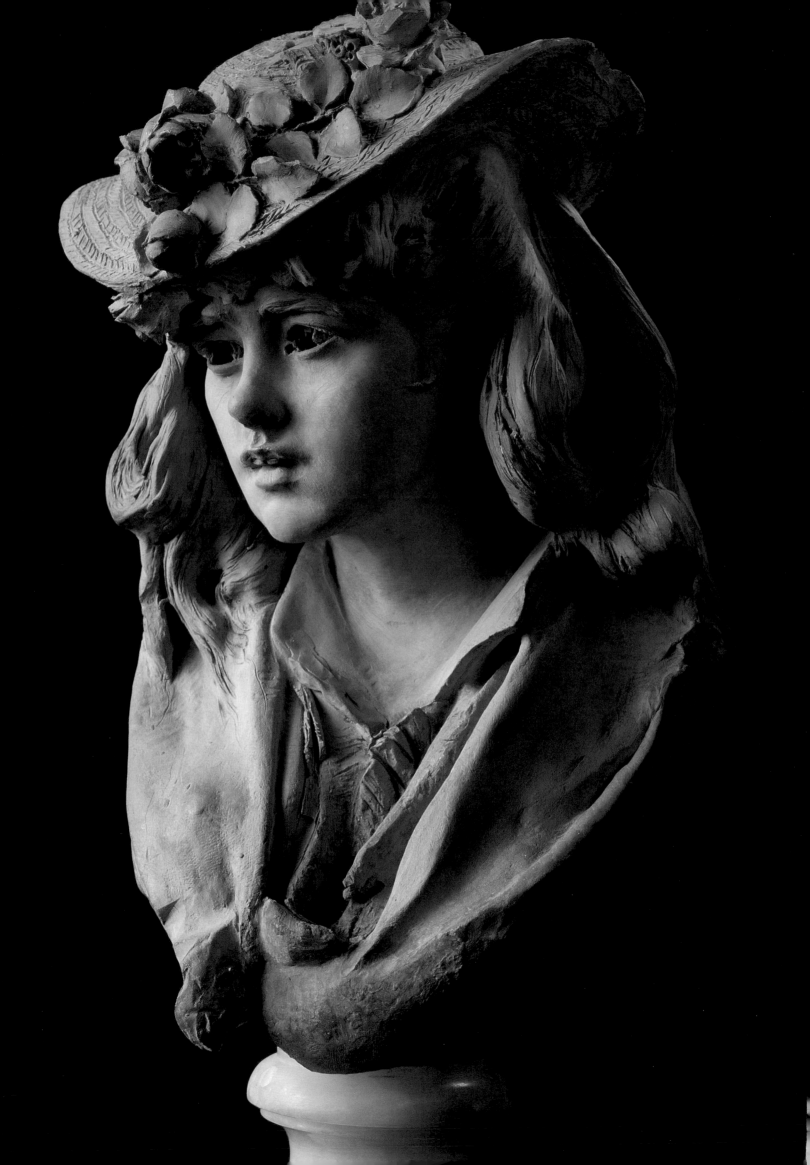

Mask of Madame Rodin

1880–82 (executed 1911), pâte de verre. Gift of Jules E. Mastbaum, The Rodin Museum, Philadelphia.

Although Rodin and Rose Beuret remained together for the most part until her death in 1917, Rodin made no portraits of her after she reached her mid-to-late thirties. The dating of all the portraits is questionable, but based on photographs this work was most likely created when Beuret was between thirty-six and thirty-eight years old.

Young Girl with Roses on Her Hat

1865–70, terra cotta. Musée Rodin, Paris.

In his early busts of women, Rodin was strongly influenced by the expressiveness of Carpeaux and the decorative elements of Carrier-Belleuse. Young, innocent, and unsmiling, the busts were decorated with fancy hats and flowers, ribbons, and the ornate tops of gowns. The smooth surfaces and heavy decorations, however, show little of the sitters' true personalities.

The Idyll of Ixelles

1876, plaster. Musée Rodin, Paris.

Once Rodin began working on his own, he
turned away from the sentimental and decorative
pieces he was required to create as an assistant to
Carrier-Belleuse. This early work of innocent
children at play is strangely reminiscent of Rodin's
later figures of men and women embracing.

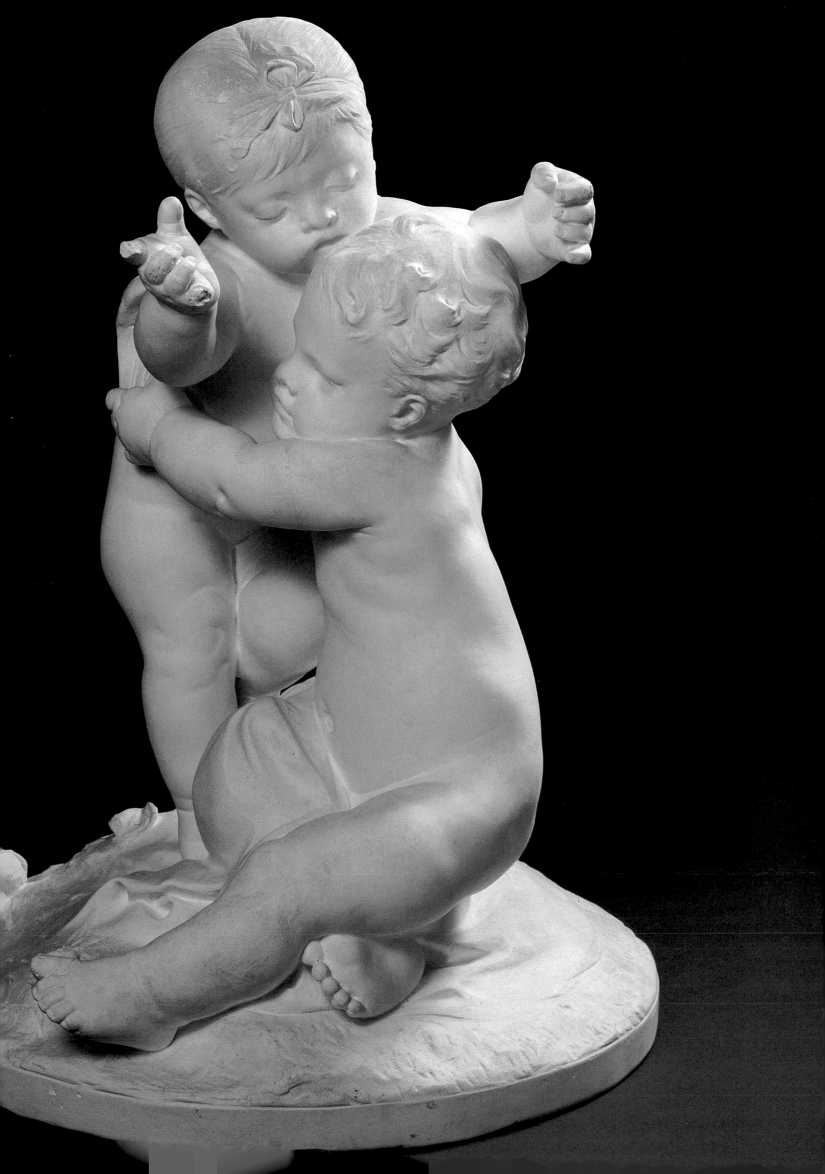

La Lorraine

1872–75, terra cotta, painted red.

Gift of Jules E. Mastbaum, The Rodin Museum, Philadelphia.

Rodin's work rarely incorporated traditional Christian symbols or themes.

Even here, the prominently displayed cross and the demure and pious expression

on the woman's face contrast strongly with the swelling, partially uncovered bosom below.

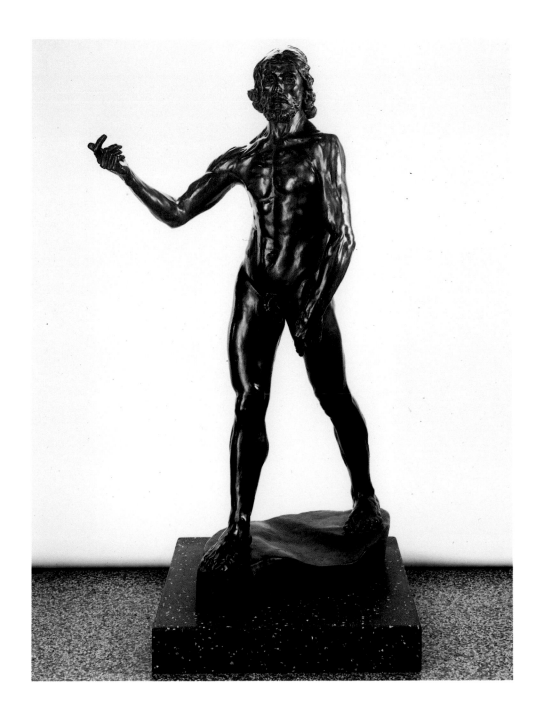

St. John the Baptist Preaching

1878, bronze. Gift of Jules E. Mastbaum,

The Rodin Museum, Philadelphia.

Rodin made his second full sculpture slightly

larger than life-size—almost 6½ feet tall (2 meters)—to lay

to rest accusations of casting that had dogged his *Age of Bronze*.

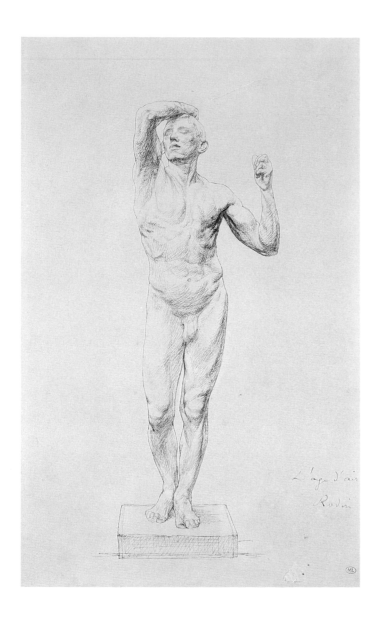

The Age of Bronze

*c. 1880, pen and ink; 12³/₈ x 9³/₁₆ in.
(31.4 x 23.4 cm). Cabinet des Dessins,
Musée du Louvre, Paris.*
This early drawing by Rodin,
done after the completion of his
sculpture, shows his considerable
talents in capturing two-dimen-
sional images on paper as well as
in three-dimensional sculptures,
especially in regard to the
detailing of the musculature.

The Age of Bronze

detail; 1875–76, bronze. Rodin Museum, Philadelphia.
Rodin studied his model Neyt for hours on end
from all angles to achieve the most faithful
representation of the body. He later told interviewer
Dujardin-Beaumetz: "I climbed up and did what I
could to make my model and my clay agree in fore-
shortening, and I looked at the contours from above."

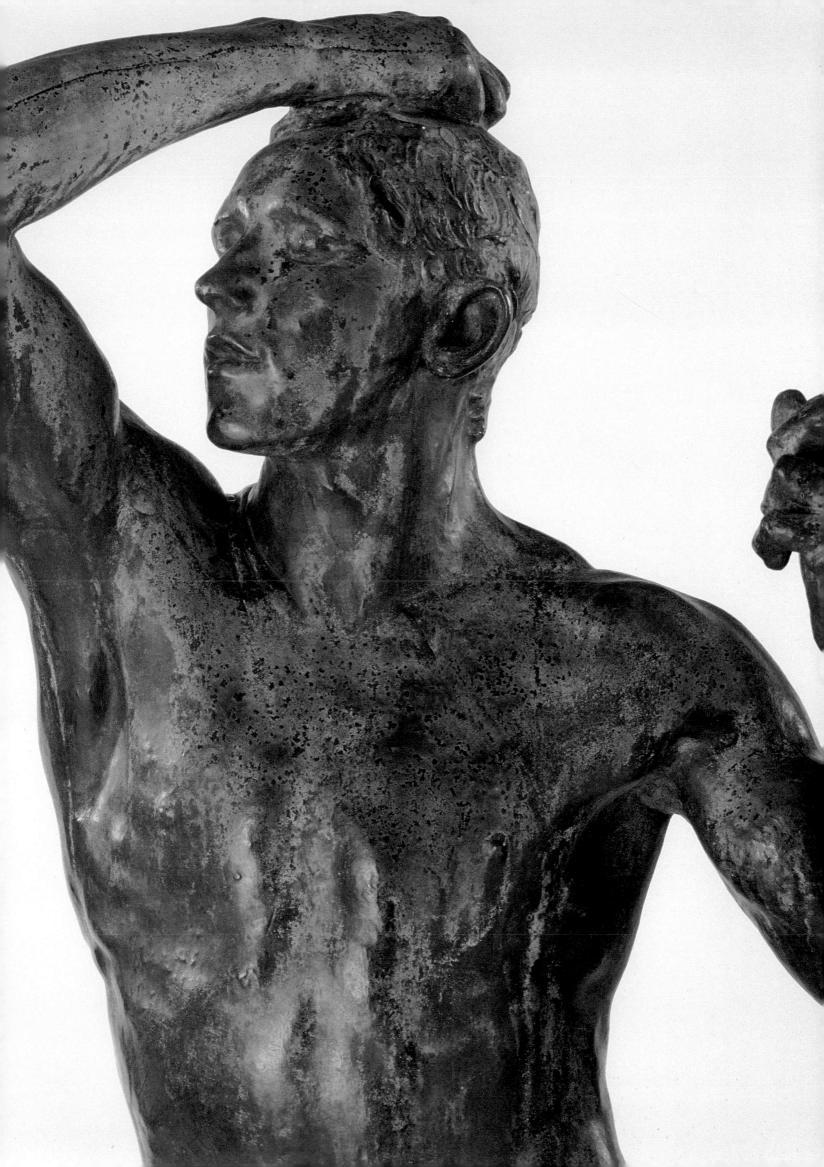

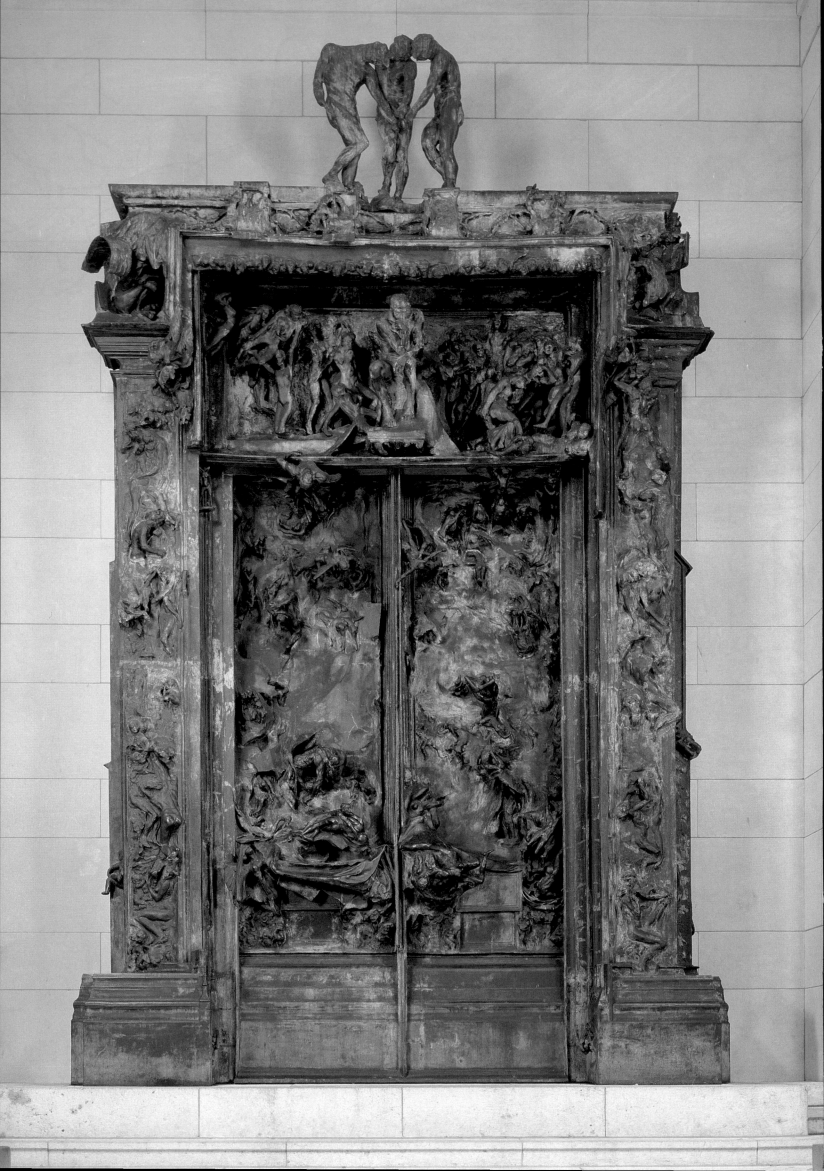

"THE GATES OF HELL" AND THE WORKS IT INSPIRED

The man responsible for approving the state's purchase of *Age of Bronze*, Edmond Turquet, the undersecretary of state for fine arts, was also instrumental in helping Rodin move on to the project that would consume him for the rest of his life.

In 1880 France was determined to build a museum that would showcase French art treasures. While trying to convince the world of the originality of *Age of Bronze*, Rodin had been in contact several times with Turquet. When it came time for the Fine Arts Commission to select an artist to create the bronze doorway intended to proclaim the function of the planned Museum of Decorative Arts, Rodin seemed a natural choice.

While substantial to a struggling artist such as Rodin, the money paid for the commission would have been negligible to a more established sculptor. And someone who already had firm commissions would likely have questioned the wisdom of agreeing to create doors for a building that had not yet been built. In fact, in the end the building never was constructed; instead it was incorporated into a wing of the Louvre. But that would not matter to Rodin, who by then was obsessed with the doors.

The Plan

The contract issued in August 1880 proclaimed Rodin's obligation to create a set of "bas-reliefs representing *The Divine Comedy*." It is likely that Rodin either chose or influenced the decision to have the doors revolve around the theme of Dante's long poem, a work that had interested him for years.

Rodin was not alone in his admiration for Dante's work, which had captured the imaginations of numerous other artists and writers of the time: Eugène Delacroix's painting *Dante and Virgil Crossing the Styx*, Honoré de Balzac's book *La Comédie Humaine*, and Jean-Baptiste Carpeaux's sculpture *Ugolino* are just a few examples of works inspired by the great poet. Rodin's drawings show figures based on themes from *The Divine Comedy* from as early as 1875.

In addition to Rodin's personal interest in Dante, especially the *Inferno* portion of *The Divine Comedy*, he reasoned that the numerous small figures required for the doors would put an end forever to accusations of casting from life. Unlike most works based on Dante by contemporary artists, Rodin did not plan to simply illustrate one incident from Dante; the sculptor proposed to show many of the scenes.

The Gates of Hell

1880–1917 (cast commissioned 1925), bronze. Gift of Jules E. Mastbaum, The Rodin Museum, Philadelphia.

The Gates of Hell, the most consuming project in Rodin's career, was never officially completed. Even with hundreds of small figures on the doors, each is complete in every detail. Rodin also made full-scale sculptures of many figures from *The Gates*.

**The Gates of Hell:
Ugolino and His Sons**

detail; 1880–1917

(cast commissioned 1925), bronze.

Gift of Jules E. Mastbaum,

The Rodin Museum, Philadelphia.

Ugolino was the other
character from Dante that
Rodin originally intended
to illustrate on *The Gates*
before the artist widened his
theme to damned souls of
all kinds, some from Dante,
some from Baudelaire, and
some from his own imagi-
nation. On the lower left
panel, Ugolino crouches over
his sons, starving to death
as punishment for his treason.

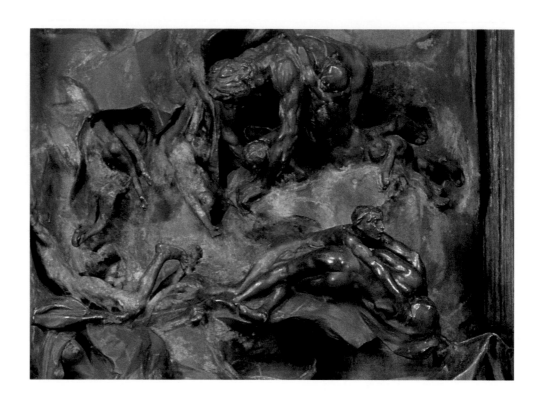

Rodin's first sketches for the doors, eventually called *The Gates of Hell*, show clear influences from Renaissance cathedral portals, although his doors were intended for a secular building, not a religious one. Like Lorenzo Ghiberti's doors for the Baptistery in Florence, Rodin at first divided his doors into eight panels, each filled with figures from a scene, with four smaller panels on each side of the doors. By the fourth sketch, he had eliminated the outer panels and was much more focused on the sculptural details of the scenes.

The architectural drawings were followed by clay models of the doors, which quickly evolved from the concept of eight panels to the final layout of two verti-cal panels and a tympanum across the top. By the third and final clay model, completed the year Rodin re-ceived the assignment, major figures from Dante such as *Paolo and Francesca*, *Ugolino and His Sons*, and *The Thinker* were all in place.

By the end of 1880, Rodin had decided on the size of the doors—at least 15 feet high and 12 feet wide (4.5 x 3.6 meters). He had also decided to flank the doors with two "colossal" bronze figures, Adam on one side and Eve on the other. Rodin was then ready to erect the first full-scale frame for *The Gates*.

The Inspiration

While the architectural design of the doors was chang-ing, the concept behind the doors was also evolving. Rodin had apparently never intended to systematically illustrate the whole of Dante's *Inferno*, instead focusing more on the scenes that stood out for him, particularly men fighting against men, men and women struggling, and men and women locked in eternal embraces. In an article by Serge Basset printed in *Le Matin* in 1890, Rodin said:

> "For a whole year I lived with Dante, with him alone, draw-ing the circles of his *Inferno*. At the end of this year, I real-ized that while my drawings rendered my vision of Dante, they had become too remote from reality. So I started all over again, working from nature, with my models."

Fourth Architectural Sketch for
The Gates of Hell

1880, pencil, ink, and wash; 21 x 15¾ in. (53.34 x 40 cm). Musée Rodin, Paris.

Before starting on clay models for *The Gates of Hell*, Rodin worked with sketches to define the structure. By this last sketch, he had moved figures that previously were to be found in each of the side panels to crouch now around the interior panels. The dark area toward the top shows the genesis of *The Thinker*.

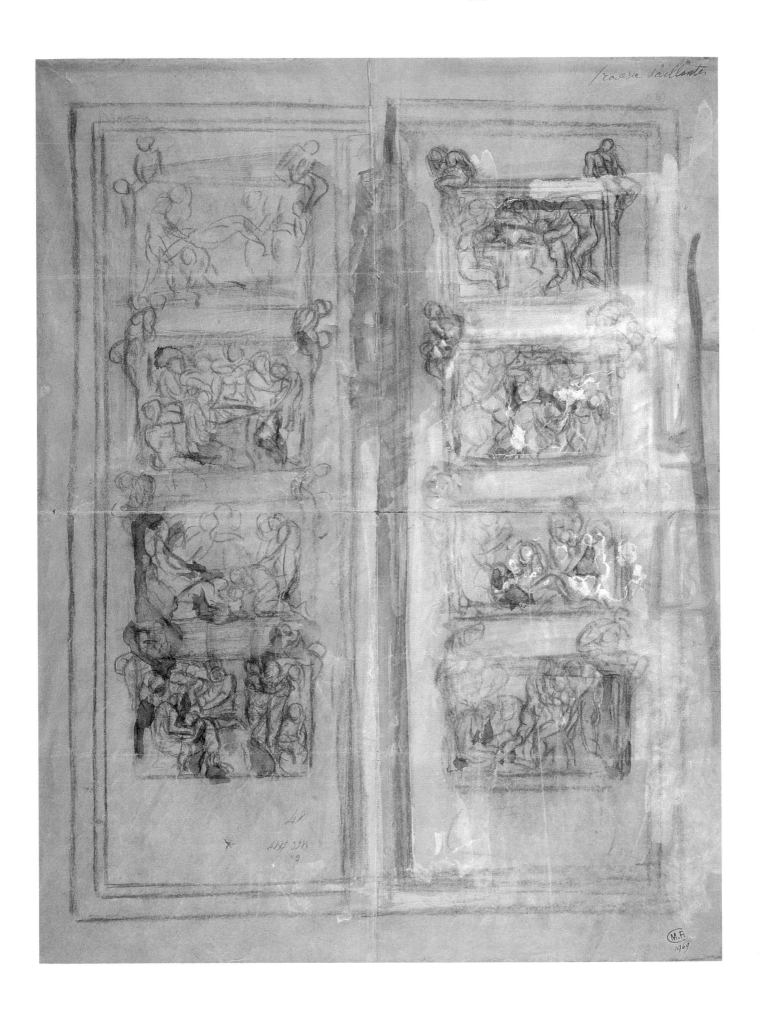

New Combinations

The figures from *The Gates of Hell* provided Rodin with inspiration for the rest of his life, as he enlarged and reduced them, translated them into plaster, marble, and bronze, and recombined figures to form new arrangements, both on *The Gates* and independently. For example, the powerful *I Am Beautiful* appears at the top of the of the right-hand pilaster of *The Gates* and also as a free-standing group. Dating from 1882, it was derived from two separate figures on *The Gates*: the *Crouching Woman*, just to the left of *The Thinker*, near his feet, and the *Falling Man*, who struggles to pull himself up only to eternally lose his grip as he reaches the tympanum below the feet of *The Thinker*.

Sometime between 1880 and 1882, Rodin created an independent figure of *Crouching Woman*; then in 1882, he put her in the arms of *Falling Man* (with minor deviations to both figures) to form what was at times variously called *The Rape*, *Carnal Love*, *The Cat*, even *The Kiss* (before the renowned *Kiss* itself acquired that title). The work's final name, *I Am Beautiful*, comes from the first line of a poem from Baudelaire's *Les Fleurs du Mal*, which Rodin had inscribed on the base:

> I am beautiful as a dream of stone, but not maternal;
> And my breast, where men are slain, none for his learning,
> Is made to inspire in the Poet passions that, burning,
> Are mute and carnal as matter and as eternal.

A similar metamorphosis occurred in the development of *Fugit Amor*, also called *Fugitive Love*. Here Rodin has combined his figure *The Prodigal Son* from *The Gates* with another female figure to create the scene at the top of the right bas-relief and then a full-scale independent work. Rodin could as easily have chosen the above quote from Baudelaire to illustrate *Fugit Amor*: In both scenes, the man desperately struggles to hold onto a woman who refuses to submit.

Another sculpture that does, however, include the same inscription on its base is *The Kiss*. One of Rodin's best-known sculptures, *The Kiss* never actually made it onto *The Gates*, although it may have originally been intended to illustrate Paolo and Francesca from the *Inferno*. In earlier versions of *The Gates*, Dante's Paolo and Francesca—who are condemned to eternal Hell for having kissed when Francesca was married to Paolo's brother—dominate, along with another scene showing Ugolino and his sons starving to death in a locked tower as punishment for Ugolino's sin of betrayal. By the final version of *The Gates*, Paolo and Francesca have decreased in importance and are locked in a horizontal embrace in the lower left panel.

It is not clear why *The Kiss* was left off the final version of *The Gates*, but one possible reason is that the seated lovers do not display the despair so evident in the other couples trapped in embraces on the doors. Although sensual and passionate, these lovers seem to *belong* with each other; they are not bound together by a momentary lapse of judgment nor does either attempt to coerce the other.

The French government commissioned a marble enlargement of *The Kiss* in 1888. However, as late as 1893, when the French government sent some of Rodin's works to the World Columbian Fair Exposition in Chicago, American authorities deemed both *The Kiss* and a grouping of *Paolo and Francesca* too risqué for public viewing. They were both put in a private room that could be entered only with special permission. *The Kiss* has since become one of Rodin's most enduring and popular works, delighting modern viewers with its warm sensuality much as *The Thinker* appeals in its cool rationalism.

I Am Beautiful (The Abductor)

1882, bronze. Gift of Jules E. Mastbaum, The Rodin Museum, Philadelphia.

At the top right of *The Gates*, and later executed as a separate grouping, this pair incorporates *The Crouching Woman* and *The Falling Man*, with minor variations to make the two fit together. The angle of the man's back, the detail of his straining muscles, and the position of his legs all display the effort involved in his carrying of this struggling woman.

The Crouching Woman

1880–82, bronze. Musée Rodin, Paris.
Possibly inspired by Michelangelo's *Crouching
Youth* in St. Petersburg, the woman here
typifies the pain of the figures on *The Gates*,
yet it is also one of contradictions: While
she folds her body to protect herself, her
widespread legs show her vulnerability. Rodin
himself worked the patina on this version.

The Kiss

1886, marble. Musée Rodin, Paris.
Because of the year in which it
was created, it is likely this
sculpture was originally intended
for *The Gates of Hell*. Here, the
woman willingly wraps her hand
around her lover's neck but
does not force him toward her.
He is involved, but the position
of his back shows some restraint.

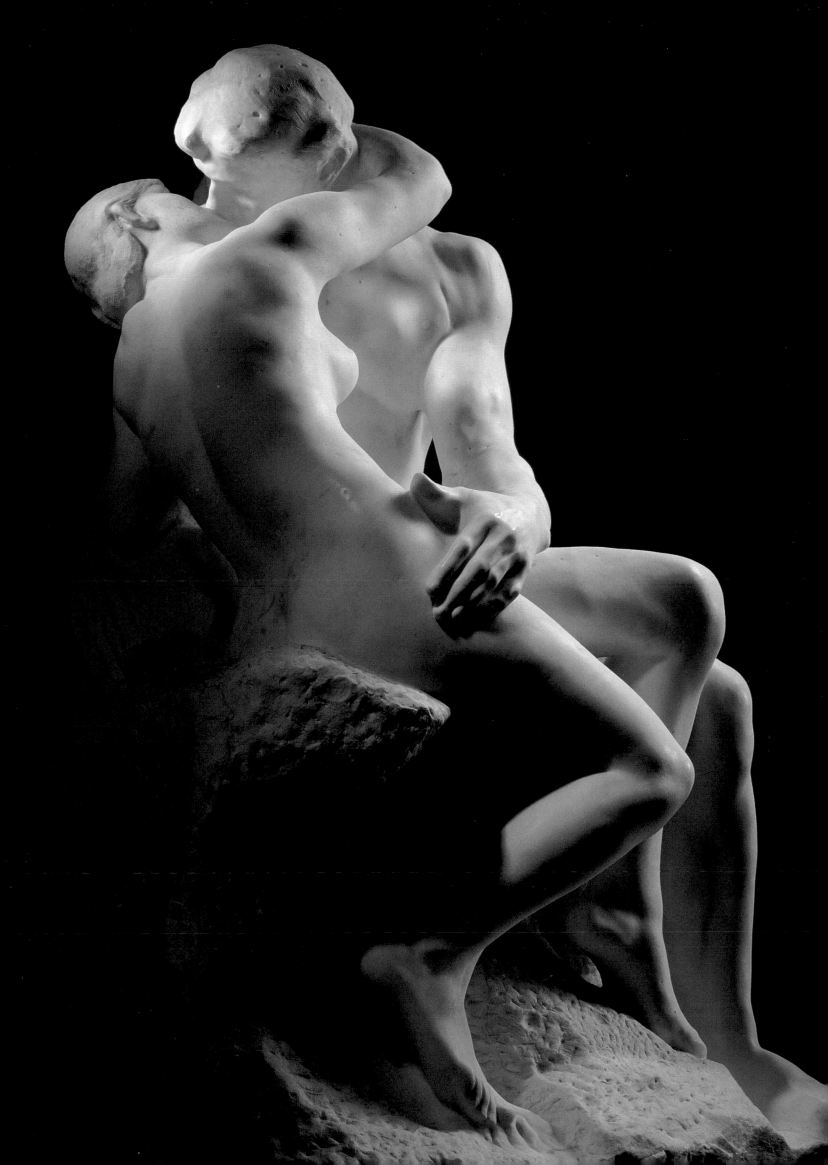

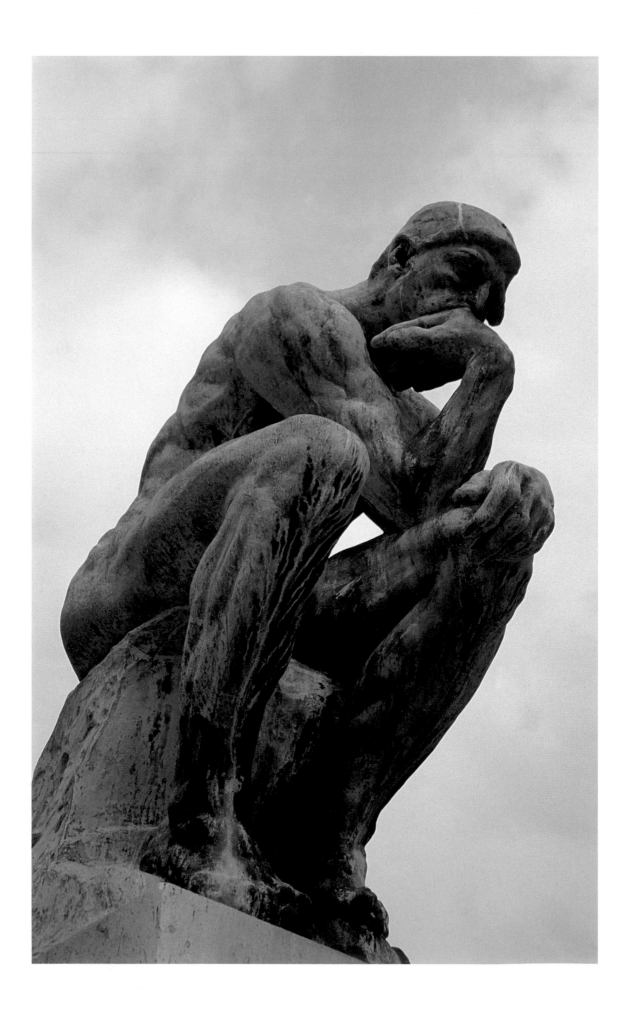

The Gates of Hell: Tympanum

detail; 1880–1917
(cast commissioned 1925), bronze.
Gift of Jules E. Mastbaum,
The Rodin Museum, Philadelphia.
Unaffected by the damned
souls that swirl around
him, *The Thinker* is lost in
contemplation. Carved in
the round and placed for-
ward, he stands out against
the bas-reliefs behind him.

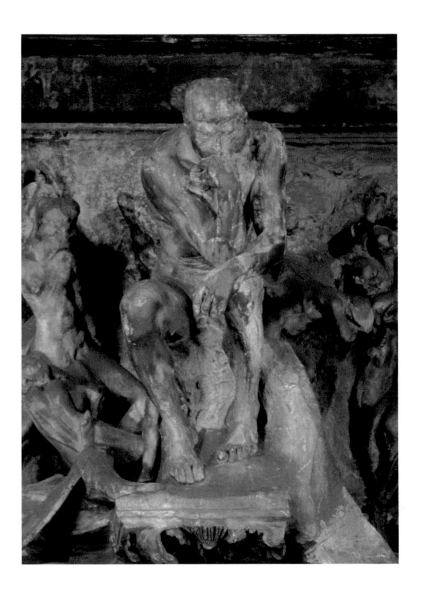

The Thinker

1880 (enlarged 1902–04), bronze. Musée Rodin, Paris.
Rodin would never comment on what his *Thinker*
thought, only how. "What makes my *Thinker* think is that
he thinks not only with his brain, with his knitted brow, his
distended nostrils and compressed lips, but with every muscle
of his arms, back and legs, with his clenched fist and gripping
toes," he told a reporter for the Toronto newspaper *Saturday Night*.

The Gates of Hell: Paolo and Francesca

detail; 1880–1917 (cast commissioned 1925), bronze.
Gift of Jules E. Mastbaum, The Rodin Museum, Philadelphia.
The lovers Paolo and Francesca, from Dante's *Inferno*,
were originally intended to dominate *The Gates*, but in the
end Rodin relegated them to the bottom left panel. The
anguish of Francesca, damned to an eternal embrace with
her lover, is evident in her blank stare and half-open mouth.

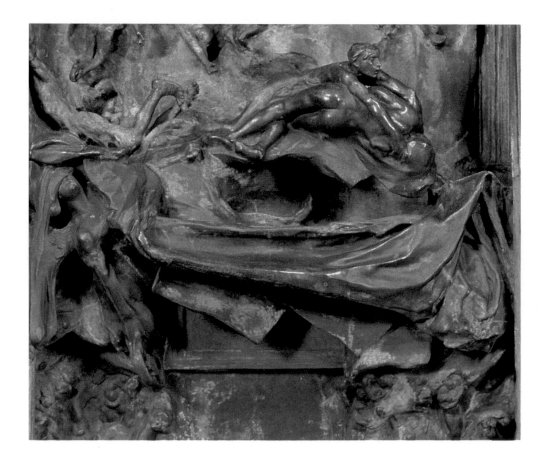

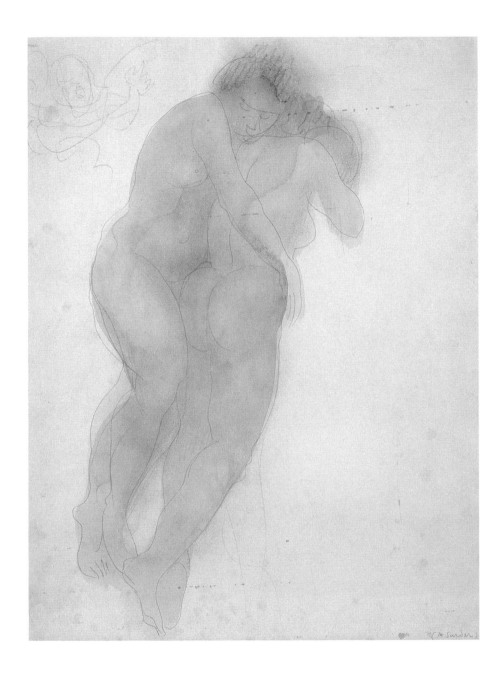

Two Nudes

n.d., pencil and watercolor on paper; 12¹³/₁₆ x 9³/₄ in. (32.6 x 24.7 cm).

Hirshhorn Museum and Sculpture Garden, Smithsonian Institution, Washington, D.C.

Rodin expressed his fascination with the female body in thousands of drawings similar to this.

He kept his eyes on the models while he drew, giving the forms shape and the sense of motion

with quick pencil lines, then correcting, refining, and enhancing with the application of a color wash.

Three Crouching Women (Three Boulders)

n.d., pencil and watercolor;
11⅛ x 14⅞ in. (28.25 x 37.7 cm).
Gift of Jules E. Mastbaum,
The Rodin Museum, Philadelphia.

Seen from the back, these three crouching women do not exhibit any of the despair evident in the sculpture. Rodin's drawing style, especially in his later years, was very simplified. With only a few lines, these bodies are complete, and even in this awkward position the figures seem alive and on the verge of movement.

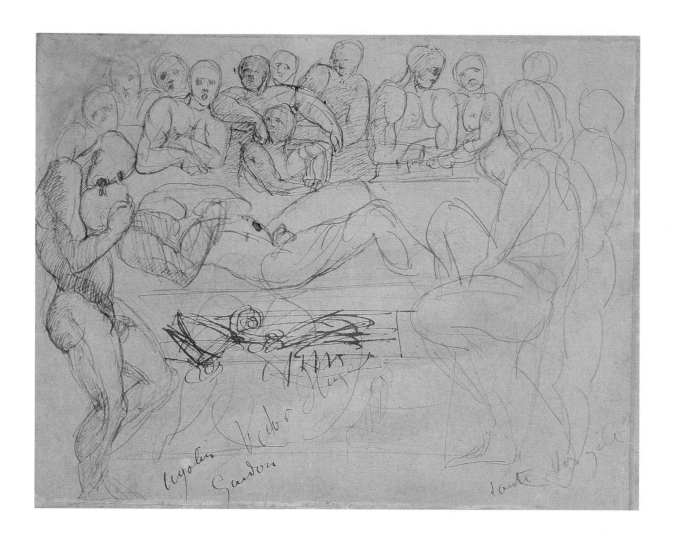

Ugolino's Feast

c. 1880, pencil and ink; 6 x 7¾ in. (15.24 x 19.6 cm).

Gift of Jules E. Mastbaum, The Rodin Museum, Philadelphia.

In his early studies, Rodin had intended some of the panels in *The Gates of Hell*

to highlight crowd scenes like the one in this preliminary drawing,

where Ugolino prepares to devour his adult son as the crowd watches in horror.

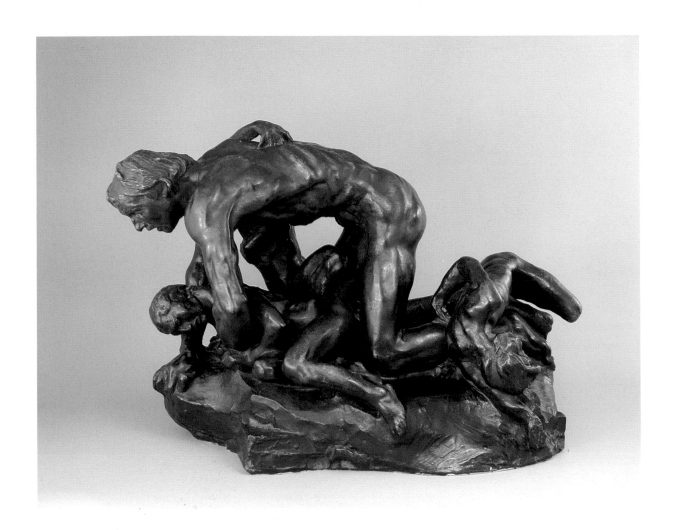

Ugolino

1882, bronze. Musée Rodin, Paris.

Although still muscular, the back, arms, and legs
clearly show the bones of a man wasting away,
starving to death. Ugolino crouches over his sons, who
flail in agony as their father prepares to devour them.

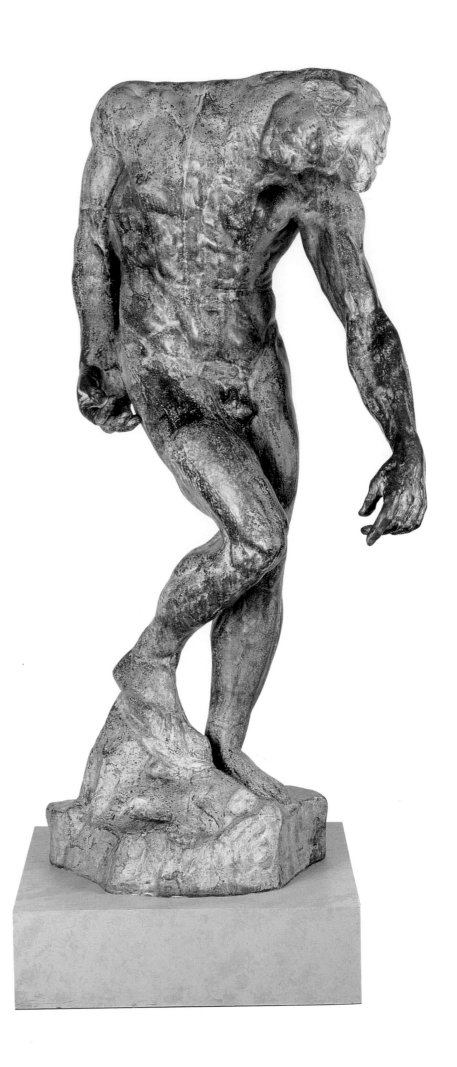

The Shade

1880 (enlarged c. 1898), bronze.
Gift of Jules E. Mastbaum,
The Rodin Museum, Philadelphia.
Based on Rodin's *Adam*, *The*
Shade's position is essentially
the same though less con-
torted, with the left arm
thrust forward rather than
hanging across the body, the
right finger no longer
extended to receive life, and
less tension in the right leg.

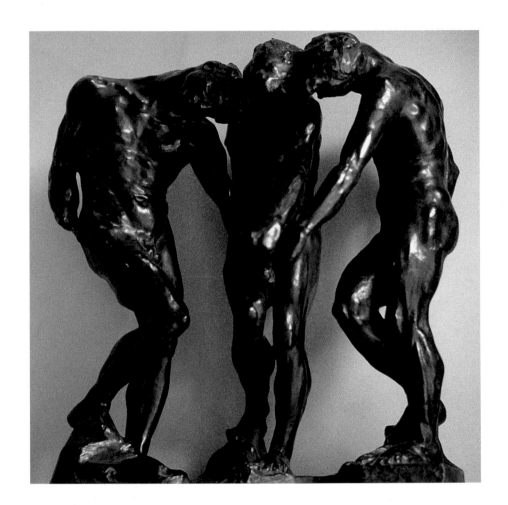

The Three Shades

1880, bronze. Musée Rodin, Paris.

Rodin grouped three identical casts of *The Shade* together to form
The Three Shades at the top of *The Gates of Hell*. In this separate grouping,
each figure is seen from a different perspective with no repetition of any contours.

The Martyr

1885, bronze. Rodin Museum, Philadelphia.

When removed from its background at the
bottom left of *The Gates*, this figure floats curiously
in space. Rodin designed no new base for it, and
he also turned it upside-down so that limbs which
fell in the original are now thrust stiffly upward.

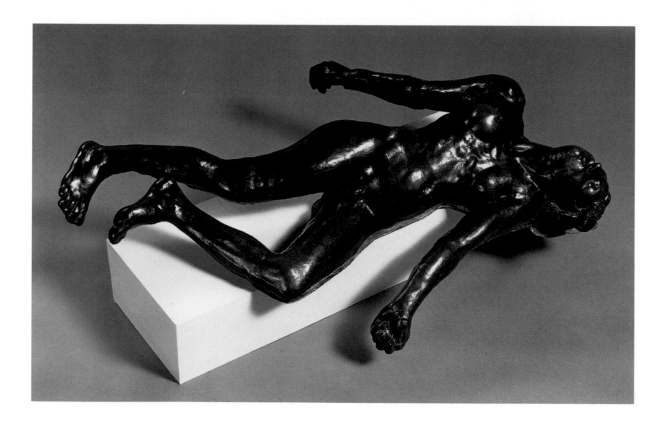

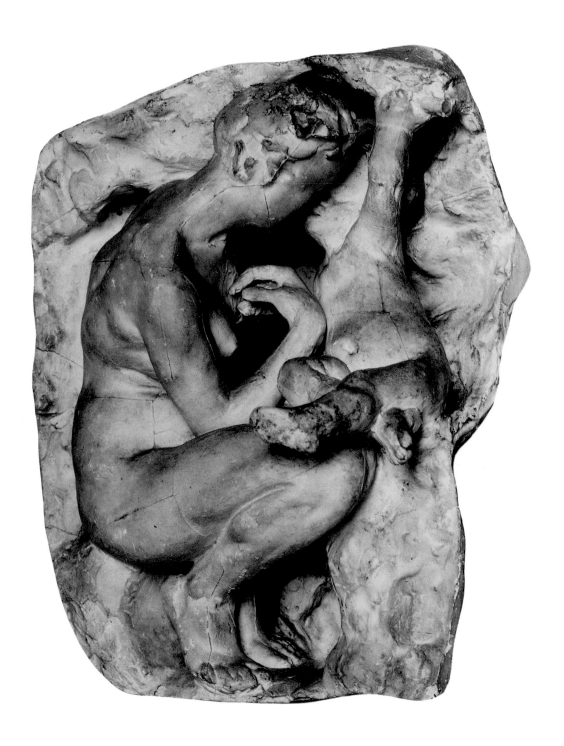

Young Mother in the Grotto

1885, plaster. Gift of Jules E. Mastbaum, The Rodin Museum, Philadelphia.

This is one of Rodin's few sculptures portraying the bond between mother and
child. It is related to a grouping at the bottom left of *The Gates* of a desperate
mother and babies, including one who has already gone over the edge of the door.

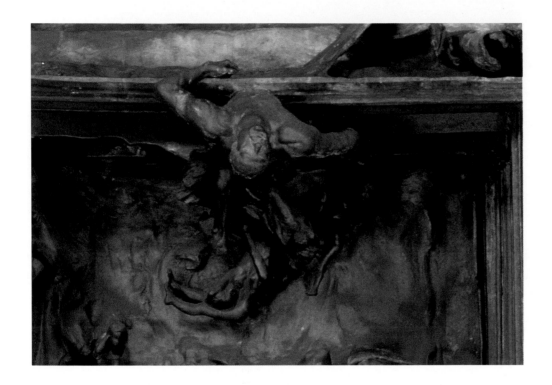

The Gates of Hell: The Falling Man

detail; 1880–1917 (cast commissioned 1925), bronze.
Gift of Jules E. Mastbaum, The Rodin Museum, Philadelphia.
One of Rodin's favorite figures, this man was repeated
in other positions in *The Gates* and removed to become
part of *I Am Beautiful* and other separate pieces. The
detail of the musculature in the back and the strong
backward arch show this man's despair as he comes
close to climbing out of Hell but once again falls back in.

The Prodigal Son

1889, bronze. Musée Rodin, Paris.
Unlike *The Crouching Woman*, who turns her
despair inward, *The Prodigal Son* seeks aid
from outside of himself in a traditional begging
position. The long lines and the expansion
of his body show his physical yearning for
help and the attempt to reach beyond himself.

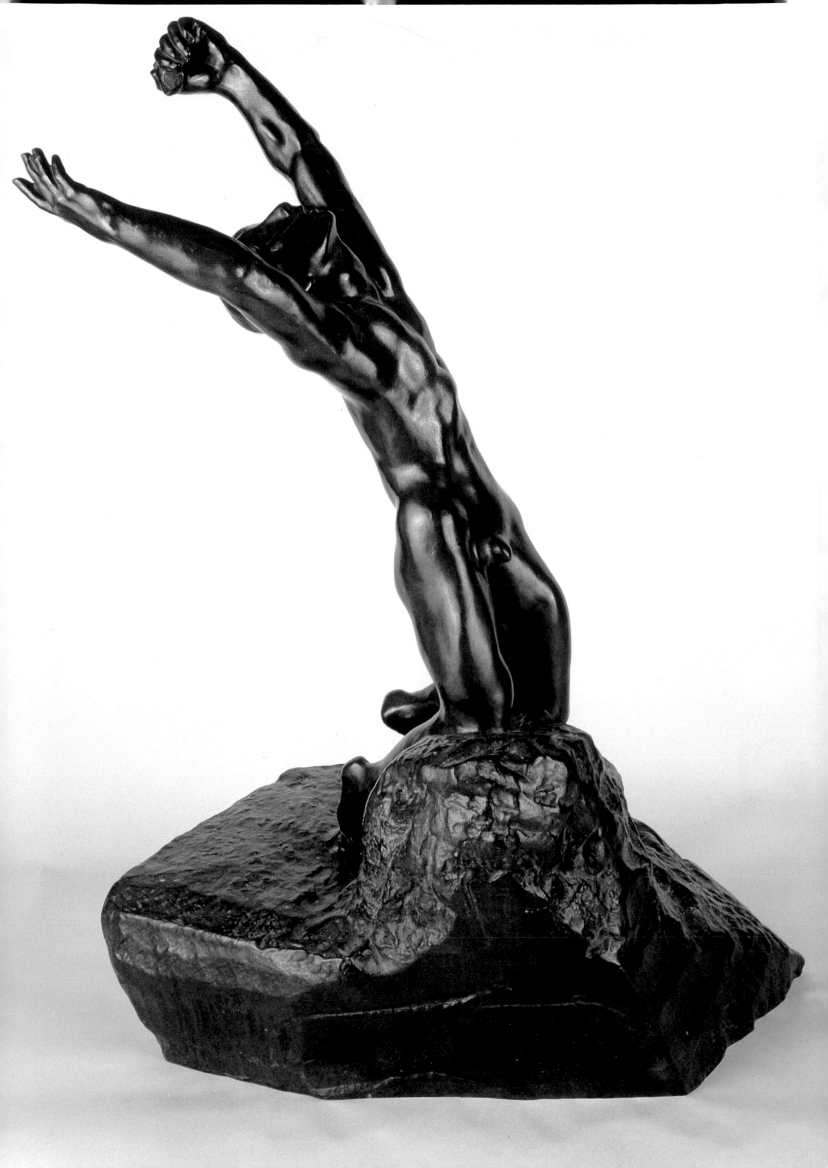

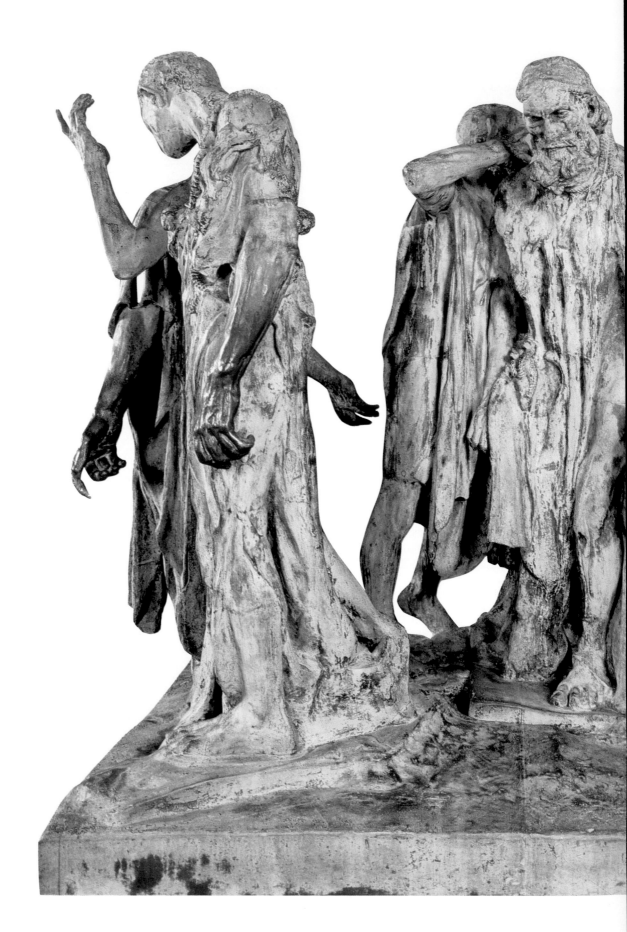

The Burghers
of Calais

1884–95, bronze. The Rodin Museum, Philadelphia. Although Eustache de Saint-Pierre is the leader of the group, it is Pierre de Wissant's hand that is first noticed, beckoning the viewer to move around the sculpture and see it from all sides. The same right hand is used for another figure in the work, Jacques de Wissant.

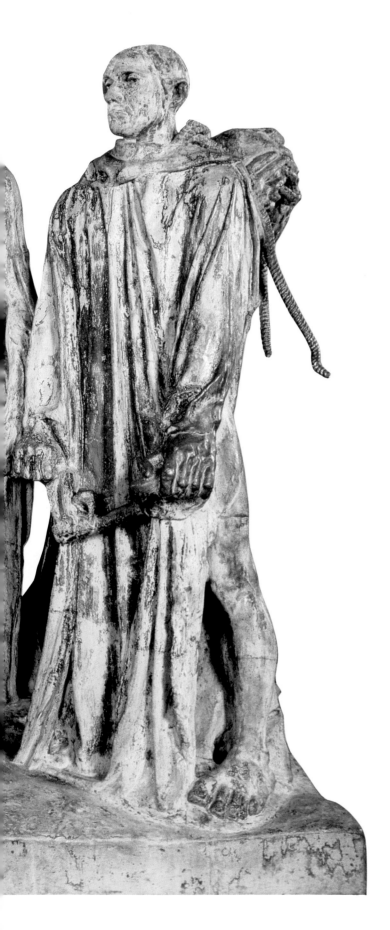

MONUMENTS AND BUSTS

In 1884, when Rodin was still at the height of his work on *The Gates of Hell*, another important commission came his way. This time, the mayor of Calais, a city in the northwestern part of France, approached him to create a monument to honor the city's hero, Eustache de Saint-Pierre. This was not the first time the city had attempted to construct a tribute to Saint-Pierre; they had been trying without success for over a hundred years, with the work interrupted at various times by war and lack of funds.

With *The Gates* still in progress, Rodin had yet to complete a public monument. This commission would give him the opportunity to finally make his name.

The Burghers of Calais

As was his habit, Rodin immersed himself completely in his new project, delving into the background of the city's hero. During his research, he discovered, as others had before him, that Saint-Pierre was not the only hero of Calais.

In 1347, a decade after the beginning of the Hundred Years' War, and after a long siege of Calais, King Edward III of England had agreed to spare the population if six of the town's principal citizens would come forth, bareheaded and barefoot, with the keys to the town and the castle. The story has it that Eustache de Saint-Pierre was the first to volunteer, providing inspiration for the five friends and relatives who followed, thus saving the town.

Rodin was immediately taken with the idea of creating a monument to all six, led by Saint-Pierre, rather than the standard city statue honoring a single hero. As he explained in a letter to Omer Dewavrin, the mayor of Calais, in November of 1884: "The idea

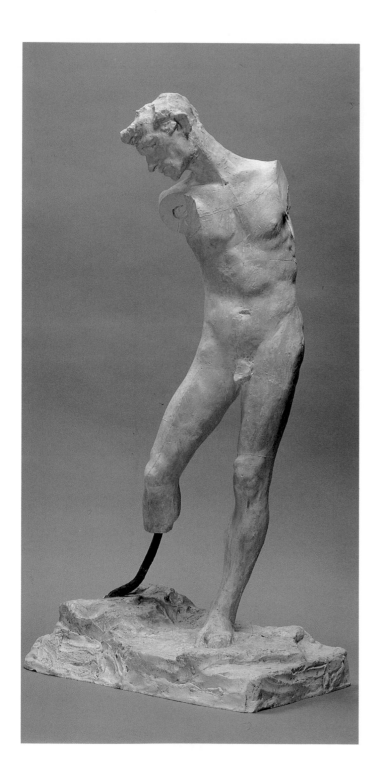

Study for the Nude Figure of Pierre de Wissant

1885, plaster. Musée Rodin, Paris.
Before Rodin put clothing on his figures for the monument, he created them as nudes to ensure the proper development of the bodies, which he considered the most important aspect of a work.

seems to me to be completely original, from the point of view of architecture and sculpture. . . . Eustache de Saint-Pierre, alone, compels and leads his relatives and friends with his dignified movement."

Other artists in addition to Rodin submitted maquettes, but the committee decided to go with his, requesting another, smaller plaster maquette before he moved on to the final version. Rodin created the figures of the burghers the same way he did all others. First he modeled a naked body, then he clothed it. On July 14, 1885, Rodin was ready to submit the maquette. In his letter to Dewavrin, Rodin wrote that the draperies clothing the bodies would be reworked as necessary when the figures were enlarged, adding: "I have my nudes, that is, the underneath part which is done, and I will have them finalized so as not to lose any time. You will understand that the most important part, the part which is not seen, is finished."

The committee members might have understood that part, but they were befuddled by other aspects of the figure. They complained that all the figures were the same height, creating "monotony and dryness." In addition to artistic criticisms, the committee stated: "This is not how we imagine our glorious fellow citizens going to the camp of the King of England. Their despondent attitudes offend our religion. . . . We believe we must insist that Mr. Rodin modify the attitudes of his figures and the silhouette of the group."

Rodin responded in August with a letter that addressed each of the points the committee had made, especially the contention that the heads should be of different heights to form a pyramid, rather than his straight line, or "cube" as he called it. The artist declared:

It is quite simply the [Grand] Ecole that is giving me rules. I am directly opposed to this principle, which has prevailed in our period from the beginning of the century and which is directly opposed to the preceding periods of great art, and results in frigidity, lack of movement, and conventionalism in works conceived in this spirit.

Despite the disagreements, Rodin continued to work on the sculpture with the reluctant approval of the committee. By the beginning of 1886 he had completed three of the figures and in mid-1886 he received some additional money. Then the project was put on hold, not by Rodin, but by the committee in Calais, as a result of the financial depression engulfing the country. Rodin continued to work on his monument, now freed from the restraints of trying to placate the committee.

Three of the burghers were shown in 1887, and in 1889 *The Burghers of Calais* was exhibited for the first time at a joint show of work by Rodin and the painter Claude Monet. In 1893, the city of Calais tried again to raise the money to have the monument installed, finally succeeding with the help of the French Ministry of Fine Arts. Even so close to the end of the project, Rodin and the committee continued to have differences. Rodin wanted *The Burghers* either on a very high pedestal so they would stand out against the sky or a very low one so the public could see into "the heart of the subject." The committee "compromised" by settling on an average height base—exactly what they had wanted from the beginning—and the monument was unveiled on June 3, 1895.

In the long run, though, Rodin did get his way. He never veered from his vision of the six men, differing as it did from the mainstream of artistic perspective. Rather than glorify the men, he tried to make them real people facing an extraordinarily difficult decision. In a 1914 article in *L'Art et les Artistes*, Paul Gsell quoted Rodin as saying: "I didn't hesitate to make them as thin and weak as possible. . . . They are still questioning themselves to know if they have the strength to accomplish the supreme sacrifice—their soul pushes them onward, but their feet refuse to walk." Rodin also got his pedestal—although he did not live to see it. In 1924, the monument was moved to the front of the Hôtel de Ville where, as originally intended, it was installed on a low base.

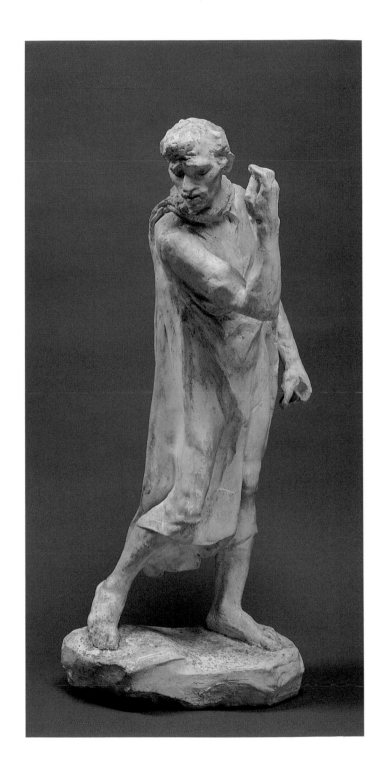

Study for the Clothed Figure of Pierre de Wissant

1885, plaster. Musée Rodin, Paris.

When Rodin was done with the nude models, he draped them in loosely flowing robes. Here, although the clothing covers the body, the movement beneath the drapery is still clearly apparent.

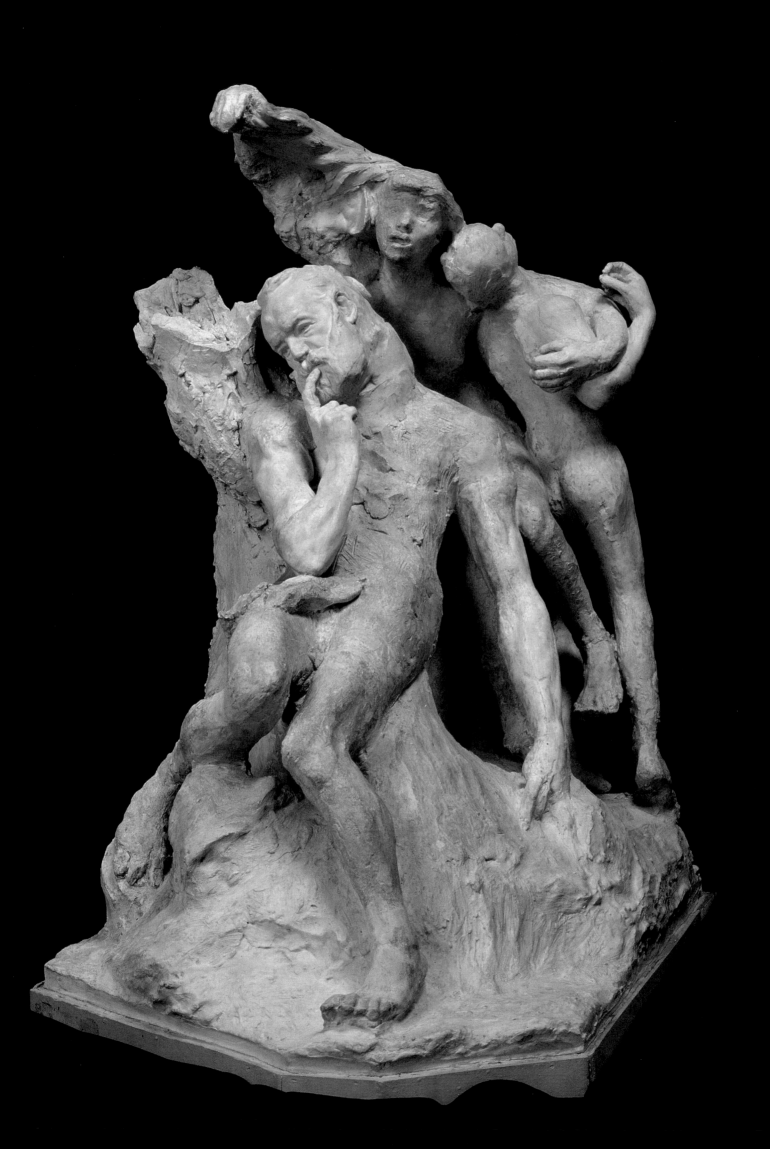

Monuments to the Greats

By the late 1880s, in addition to *The Gates of Hell* and *The Burghers of Calais*, Rodin was hard at work on a number of projects. They included public monuments to the French painter Jules Bastien-Lepage, a friend of his who had died in 1884; the seventeenth-century French "painter of light" Claude Lorrain; and renowned French poet and novelist Victor Hugo.

Before Hugo's death in 1885, Rodin had had limited contact with the great man. In 1883, in an unusual situation, Hugo decided not to sit for a bust Rodin wanted to make (Hugo believed that the bust done of him by David d'Angers could not be improved upon

by anyone) but did agree to allow Rodin to observe him. In the process, Rodin made good use of the training provided by his Petite Ecole teacher, Lecoq de Boisbaudran, who had taught his students how to work from memory. In the end, Rodin produced approximately eighty sketches of Hugo, drypoints, an engraving, and two busts with numerous variations. In 1889 these would all provide a foundation for a coveted new Hugo project awarded to Rodin.

Mirroring the wild swings in French politics of the late-eighteenth and nineteenth centuries, the building originally constructed as the Paris Panthéon in 1781 was donated several times to the Catholic Church to

Monument to Victor Hugo (Second Project)

1890, plaster. Musée Rodin, Paris.
In his second project for a monument in the Panthéon, Rodin has now clothed Hugo and his knees are covered with a rug. The clothing adds bulk to the figure, giving him an air of importance. The committee objected to the three muses surrounding the figure, saying that they form a confused mass when seen from a distance.

Monument to Victor Hugo (First Project)

1889–90, plaster. Musée Rodin, Paris.
From the beginning, Rodin had decided to portray the great French writer on the rock of Guernsey, to which Hugo had been exiled for his opposition to Napoleon III. In this first project for a monument in the Panthéon, Hugo sprawls naked, his hands childishly touching his lips, while three muses hover behind him.

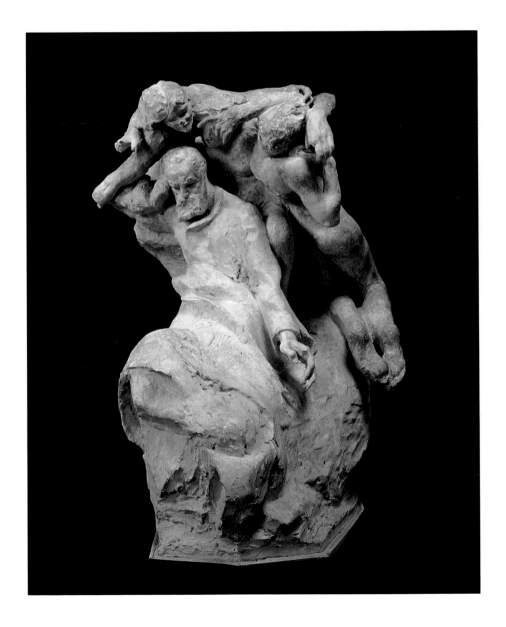

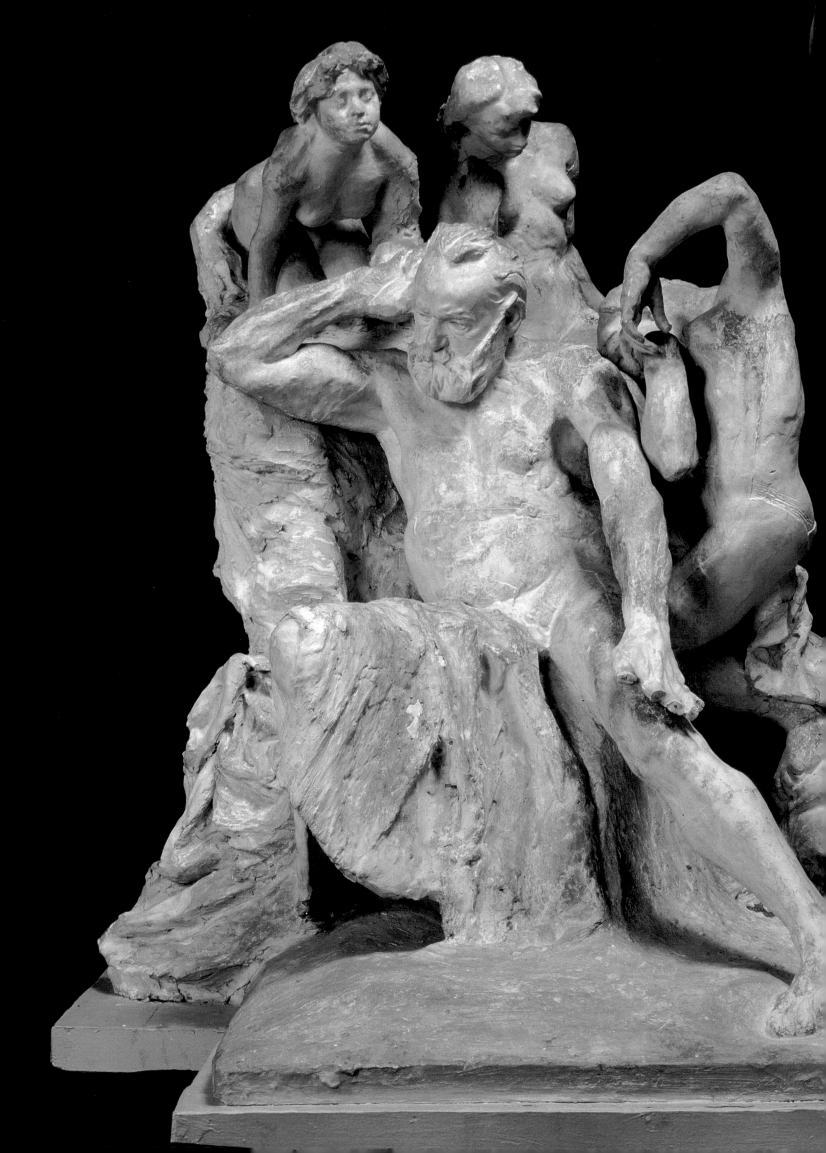

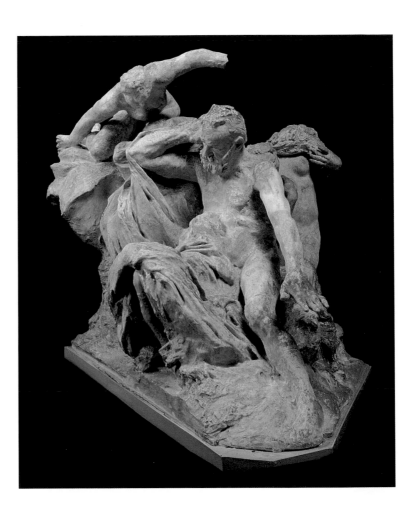

Monument to Victor Hugo (Fourth Project)

1891–97, plaster. Musée Rodin, Paris.

In the final project before the execution of the monument to the French author, Hugo's body has clearly taken on the shape and size of a middle-aged man and the drapery has been developed to present more unity. One of the muses has been eliminated, and the muse on the side carries a load upon her shoulders.

Monument to Victor Hugo (Third Project)

1891–97, plaster. Musée Rodin, Paris.

Although it was decided that Rodin would conceive an entirely separate monument to Hugo for the Panthéon, he continued to work on this grouping, which was intended to be placed in the Luxembourg Gardens. In this third project, the clothing has again been removed from the figure. The muses now appear as three individual entities rather than one entwined mass.

become the Church of Ste.-Geneviève; each time the conversion was short-lived and the building was de-consecrated to again become the Panthéon. A few years after its final transformation back to the Panthéon in 1885, the state chose several sculptors to erect monuments within the building to important French personalities, among them the eighteenth-century politician Gabriel-Honoré de Mirabeau, whose monument would be created by Jean-Antoine Injalbert, and Victor Hugo, Rodin's assignment.

Rodin decided to portray Hugo on the rock of Guernsey, after the author's exile from France in 1851 as a result of his opposition to Napoleon III. In Rodin's first plans, Hugo sprawls naked on the rock with three muses—Youth, Maturity, and Old Age—behind him. Not surprisingly, Rodin's vision once again was not in accord with that of the decision-makers. The commit-tee wanted Rodin's figure to complement Injalbert's standing monument to Mirabeau, which they had ap-proved wholeheartedly.

By this time, though, it had become increasingly dif-ficult to dictate convention to Rodin, whether in artis-tic standards or the method of representation, in part because of the reputation he had acquired with critics and the public alike. In early 1888, the artist had been decorated as a *chevalier* of the Legion of Honor, an award by then considered bourgeois by some artists but cherished nonetheless by Rodin. He had become friends with, and was championed by, some of the most influential art critics of the time, both in France and abroad. Commenting on the joint exhibition in 1889 of Monet and Rodin, the powerful critic Octave Mirbeau wrote in *l'Echo de Paris*: "It is they who, in the present century, most gloriously and definitely em-body the two arts of painting and sculpture."

Rodin had thus become too important for a committee to simply dismiss. Instead, a compromise was reached. Rodin would make his Hugo monument exactly the way he wanted and it would be placed in the Luxem-bourg Gardens in Paris; in the meantime he would also construct a completely new monument to Hugo which would achieve better placement in the Panthéon.

In 1909, Rodin's monument of the seated Hugo, the lower part of his body now covered with drapery and the muses eliminated, was erected in the gardens of the Palais Royal, where it remained until 1933 when it was moved to the Musée Rodin. In 1964, the city of Paris had a version cast in bronze, with two muses, for the corner of avenues Victor Hugo and Henri Martin. Although Rodin, as late at 1914, was still talking about delivering the monument for the Panthéon, it was never completed.

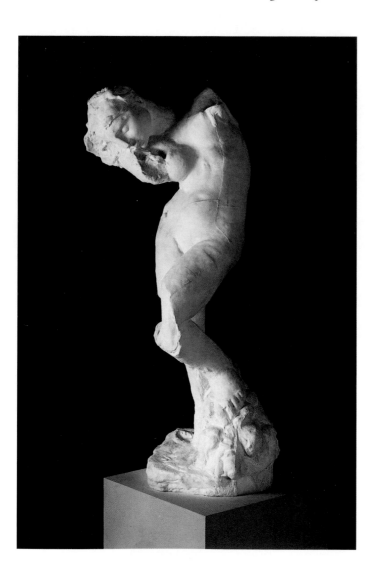

The Inner Voice (Meditation)

1896–97, plaster. Musée des Beaux-Arts, Marseilles.
Originally a figure on *The Gates of Hell*, then the muse at the side of Hugo in the sculptor's fourth projected work on the author, *The Inner Voice* was given a life of its own in several versions. In this one, Rodin left the knees incomplete where they come in contact with the drapery from the Hugo monument; in addition, the arms are broken.

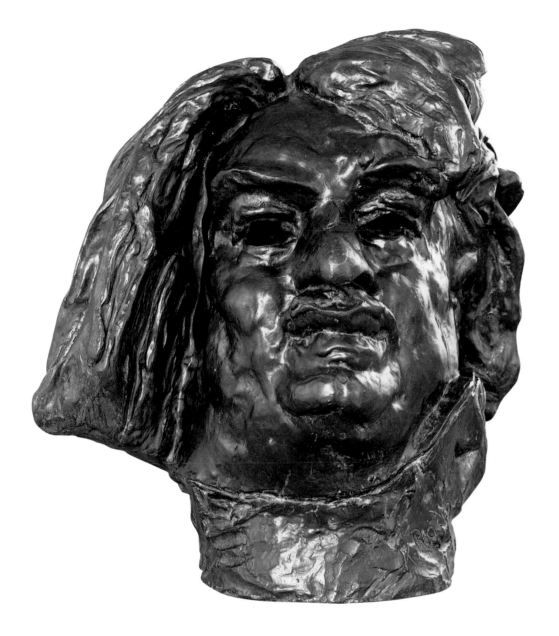

**Colossal Head
of Balzac**

1897, bronze.

Gift of Jules E. Mastbaum,

The Rodin Museum, Philadelphia.

In addition to constant
rearrangement of the
drapery, Rodin make
several slight modifications
of the head in the final ren-
dering of *Balzac*. This head
is almost identical to the
final version, with its long
hair, puffy, aged cheeks,
and unusual set of lips.

The Balzac Affair

The controversy that had swirled in the background of
so many of Rodin's projects would soon come to over-
shadow his next work, a monument to the celebrated
French writer Honoré de Balzac. Author of *La
Comédie Humaine* and a founder of the Société des
Gens de Lettres, Balzac had died at the age of fifty-one
in 1850. Like *The Burghers of Calais*, numerous at-
tempts had already been made to commission a mon-
ument to Balzac, but it was not until 1891 that the
society, under the leadership of then president Emile
Zola, approached Rodin to execute the monument.

From the beginning there were problems, with ac-
cusations in the press that the jury to select Rodin had
been rigged. Optimistic as ever, Rodin proposed to de-
liver a 10 foot (3 meter) monument within eighteen
months. Without a living person to model from, how-

ever, Rodin was at a loss. He studied other sculptures
of Balzac, pored over photographs and drawings,
reread the great author's works, and finally went to
Balzac's birthplace, hoping to better understand the
writer. There he discovered a postman, who looked
like Balzac, to model for him, and also Balzac's old tai-
lor, whom Rodin asked to make clothes in Balzac's
measurements.

For a while, everything seemed to be going well.
When the committee saw the first maquette in late
1891, they immediately approved the figure, dressed
in Balzac's customary white monk's robe. However, in
June of 1893, a month after the monument was to be
delivered, Rodin said that it would not be completed
for at least another year. Rodin now had three missed
deadlines hanging over his head: the *Burghers* and the
two versions of the Hugo monument in addition to

this monument to Balzac. As always, *The Gates of Hell* remained a work in progress in the background.

At a loss as to how to proceed, in October of 1894 the committee from the Société debated the merits of ordering Rodin to deliver his sculpture within twenty-four hours or returning the ten thousand francs he had already been paid. A compromise was reached when Rodin agreed to hand the money over to a third party to hold until the sculpture was delivered—provided he could have more time to complete it. As a result of the arguments within the Société, Jean Aicard, who had followed Zola as president, resigned along with six other members.

In December, Rodin received a letter from Zola, then traveling in Venice, in which the writer pleaded, "I beg you, in the name of genius, in the name of French literature, do not make Balzac wait any longer." Nearly two years later *Le Temps* announced that Rodin had finished his studies for *Balzac;* the following year the Société declared that the maquette had been completed and the enlargement was proceeding. Finally, the plaster enlargement was ready for the Salon of 1898, exhibited across the way from Rodin's marble version of *The Kiss*, which had been commissioned by the state in 1888 and recently completed.

Balzac was the talk of the Salon. Critics who attended reported overhearing comments that called the figure "a snowman," "a madman . . . wearing his hospital gown," "a side of beef," "a bag of plaster." Other critics declared it "an obese monstrosity," "a colossal fetus," and "a practical joke." The committee had this to say in a letter to Rodin: "The committee of the Société des Gens de Lettres is regretfully obliged to protest the rough model that Monsieur Rodin is exhibiting at the Salon and declines to recognize it as a statue of Balzac."

Friends immediately came to Rodin's support, composing a letter of protest and creating a fund to purchase the monument themselves. Monet wrote to Rodin: "Let them protest all they like—you have never achieved so much before." The committee took back the ten thousand francs and turned the commission over to Alexandre Falguière, who was—and remained—a friend of Rodin. Yet that did not end the controversy. It quickly became apparent that many of

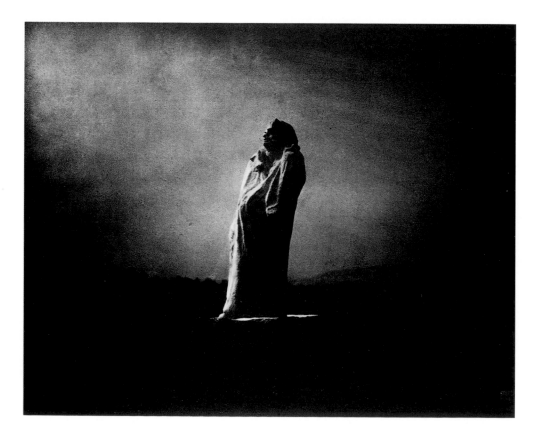

Rodin: Balzac Moonlight Series

EDWARD STEICHEN; *1908, photograph.*
Gift of Mrs. Charles B. Grace,
Philadelphia Museum of Art.
When finally shown in public, this sculpture led to the greatest controversy of Rodin's beleaguered career. In response, Rodin removed it from the Salon and brought it to his home in Meudon, where this photograph was taken.

Balzac

1897, bronze. Gift of Jules E. Mastbaum,
The Rodin Museum, Philadelphia.
In the final version of this notable work, Rodin decided to clothe Balzac in the monk's robe that the writer had been known to wear. Rodin worked ceaselessly with the drapery, trying numerous arrangements.

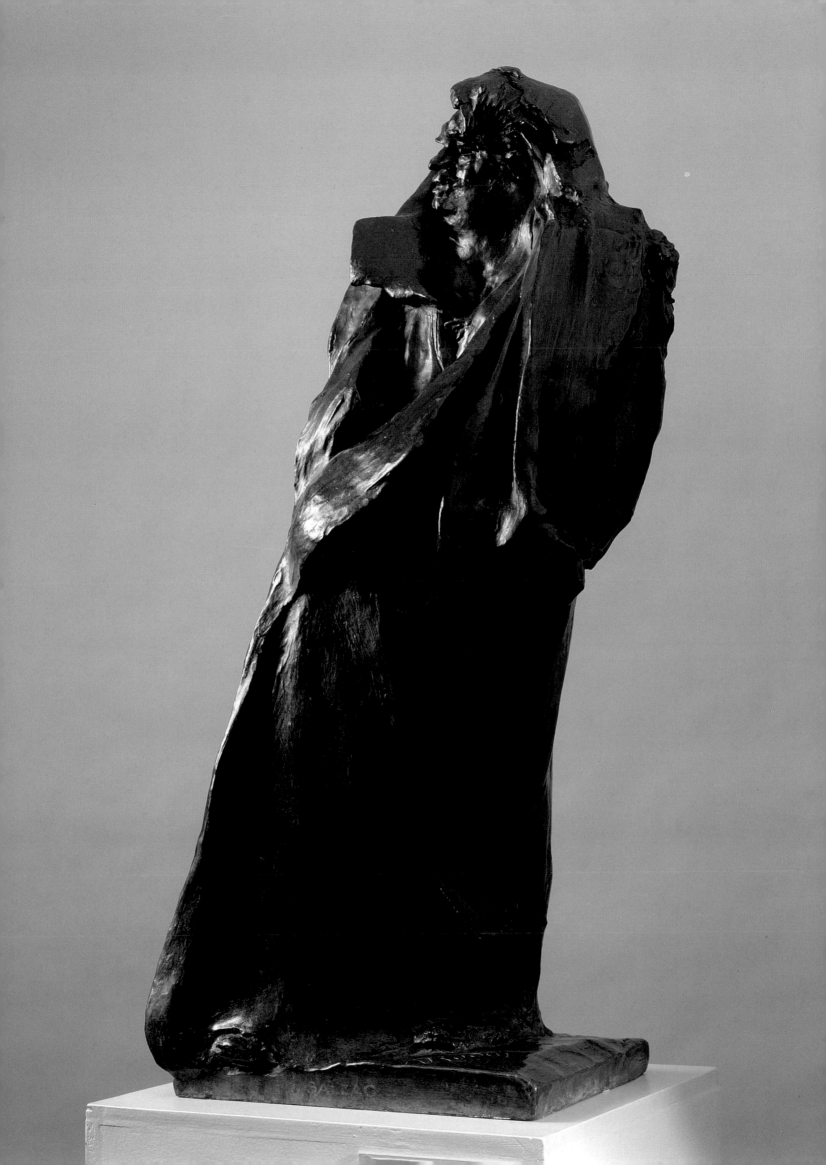

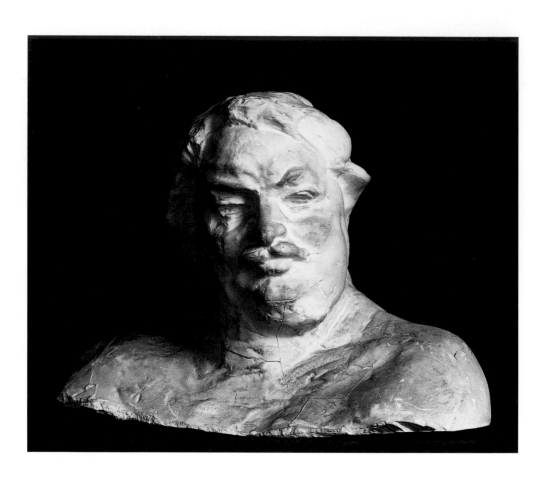

Head of Balzac

*1892, plaster. Gift of
Jules E. Mastbaum,
The Rodin Museum,
Philadelphia.*
Rodin made numerous
studies of the writer's
head alone, some from
photographs and some
from live models. This
one is thought to be a
combination of the two
techniques, its lifelike
expression probably
coming from a model
and its resemblance to
the actual Balzac likely
the result of photographs
Rodin had studied.

the artists, writers, politicians, and other leading figures who had taken up Rodin's defense were the very same people who had rallied to the support of Alfred Dreyfus, the French army captain who had been accused of treason in 1894.

By 1898, the year Rodin exhibited his *Balzac*, the disagreements over what had come to be called the "Dreyfus Affair" had permeated the very heart and soul of late-nineteenth-century French society, pitting royalist, nationalist, and Roman Catholic factions against republican, socialist, and anti-clerical groups. Zola, who had remained steadfast in his backing of Rodin's figure in the seven years since it had been commissioned, clearly stated his support of Dreyfus in his famous article "*J'accuse*"—and was promptly sentenced to jail for libel, a term he was able to escape by fleeing to England. Support for Rodin poured in from celebrated artists such as (in addition to Monet) Henri de Toulouse-Lautrec, Pierre-Auguste Renoir, and Camille Pissarro, and well-known writers like Stéphane Mallarmé, André Gide, Georges Clemenceau (who later became French

premier), Henri Becque, among a host of others.

Although Rodin's own views on the Dreyfus Affair are not clear, it is evident he had no desire to become a symbol of larger political issues. Rodin withdrew *Balzac* from the Salon and moved it to his home in Meudon. In an open letter, he declared, "It is my firm wish to retain sole possession of my work." He refused to allow the monument to be cast in bronze or to be purchased, fielding offers from the group that had collected funds in his defense, a private collector, and the Maison d'Art in Brussels. Rodin strove to put the controversy in perspective that year in an interview with Camille Mauclair in *La Revue des Revues*: "Nothing I have ever done has satisfied me as much, because nothing has cost me as much, nothing sums up so profoundly what I believe to be the secret law of my art."

Two bronze copies were made in 1930, thirteen years after Rodin's death, and in 1939, on the eve of World War II, the *Monument to Balzac* was installed at the intersection of the Paris boulevards Raspail and Montparnasse.

Portrait Busts

Not everything Rodin did in the 1880s and beyond was controversial. While he was engaged in developing monuments that inevitably led to some sort of public reaction, he was also enjoying a fine reputation as a creator of portrait busts, both professionally and often as gifts to friends.

Although apparently shy, from the 1880s on the sculptor was a frequent and popular guest at the fashionable salons of such renowned hostesses as Madame Charpentier, who frequently received artists as well as writers like Emile Zola and Alphonse Daudet, and Juliette Adam, a woman known for her progressive philosophical, political, and social views who had founded the *Nouvelle Revue* and entertained noted politicians such as Léon-Michel Gambetta and Antonin Proust.

Rodin had kept in touch with a friend from the Petite Ecole, Alphonse Legros, a French painter and printmaker who had moved to England. To commemorate their friendship, Legros made an oil

portrait of Rodin and Rodin made a bronze bust of Legros. During Rodin's first visit to England in 1881, Legros introduced him to William Ernest Henley, a writer and the publisher of such luminaries as Rudyard Kipling, H. G. Wells, Henry James, and Robert Louis Stevenson. Shortly after their meeting, Henley became editor of the British *Magazine of Art* and was able to use this position to help make Rodin better known in England. Rodin insisted on creating a bust of Henley to thank him.

Within his own country, Rodin was also making important connections. One of the first art critics to champion him, Edmond Bazire, of the magazine

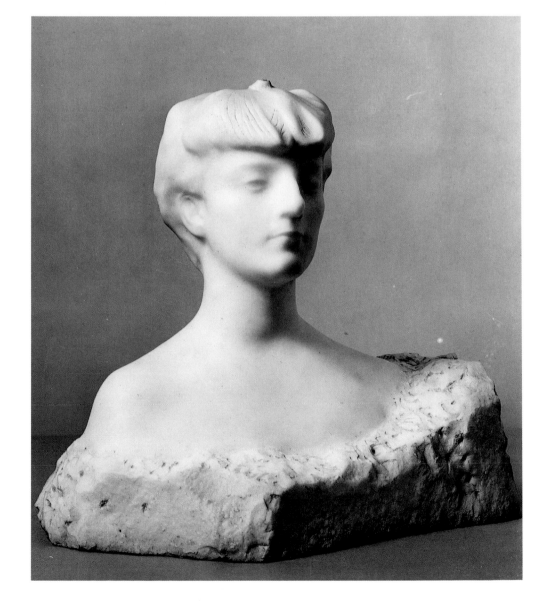

Portrait of Madame X (Comtesse Anna de Noailles)

1906, marble.

Gift of Thomas F. Ryan, 1910,

The Metropolitan Museum of Art, New York.

Well known in Parisian society for her poetry, the Comtesse herself chose Rodin to do her portrait but was not pleased with the result, especially the bump on her nose that other artists usually eliminated.

She declined to purchase it and when Rodin sold it to the Metropolitan Museum of Art, she refused to allow her name on the piece.

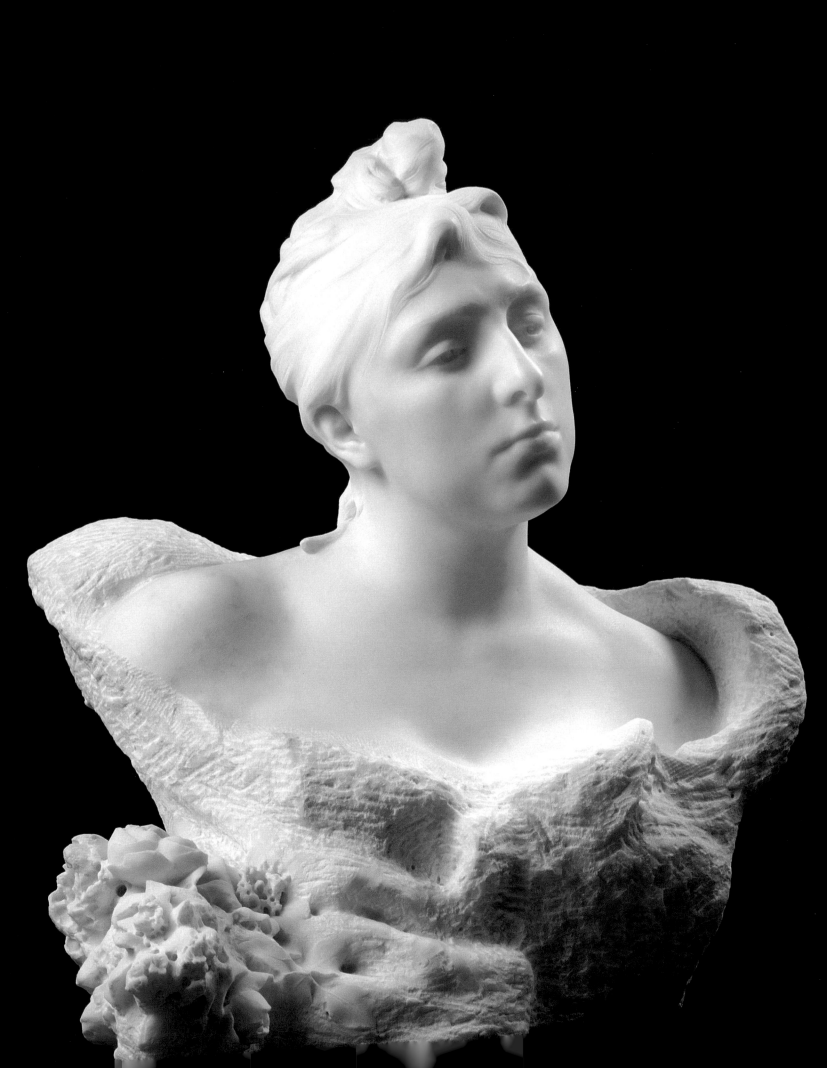

Intransigeant, suggested Rodin make portrait busts of important men to further establish his reputation. Bazire thought Victor Hugo would be a real coup for Rodin and went so far as to present Rodin to the writer at a dinner, which eventually led to Rodin's being permitted to sketch the great man.

In 1885 Rodin met Octave Mirbeau, another critic who would become both friend to and constant supporter of Rodin, and whose devotion to Rodin was so great that it was eventually mocked in the satirical song "Rodin Is Sculptor, Mirbeau Is His Prophet." Like Mirbeau, the critic Gustave Geffroy also became a friend and ceaseless defender. Rodin made busts of both these men who were so important to him. His support from critics and continuing relationships with important artists of the time, including Legros, Dalou, Monet, Falguière, and others, continued to lead to personal relationships with writers, politicians, and other public figures, which in turn resulted in additional commissions.

In 1884 alone, for example, Rodin executed busts of William Henley; the politician and eventual minister of fine arts Antonin Proust; and the wife of artist Alfred Roll, another graduate of the Petite Ecole. The same year, Rodin did a marble bust of Luisa Lynch de Morla Vicuña, the wife of the Chilean ambassador to Paris. Also called *The Charmer* and *Girlhood*, the details and sensuality of the bust immediately made a positive impression—so much so that the French government asked for and was granted permission to purchase it from the Vicuñas.

Mme. Vicuña

1884, marble. Musée Rodin, Paris

Also called *The Charmer* and *Girlhood*, this portrait bust of Luisa Lynch de Morla Vicuña, the wife of a Chilean diplomat, was one of Rodin's first of a "society" woman. Carved from a single piece of marble, the bust was immediately popular and became a sort of prototype for Rodin's later busts of women.

In *Les Lettres et les Arts* in 1889, Geffroy described *Madame Vicuña* thus: "With an easy decisiveness, he evokes the woman of today, the reserved face of the fashionable woman, the physical suppleness of a lively, high-strung creature." Rodin's approach was simple but powerful—a well-defined head and face atop bare shoulders, below which the textured top of the gown functions as a base. Geffroy went on to describe how the artist had made apparent "the warmth of the breasts, the delicate swelling of the moist lips, the flow of the glance through the long, narrow eyes . . ."

The success of this bust would eventually lead to commissions, especially in the United States and England, for the numerous "society" portraits that would become a primary source of income for Rodin in the early twentieth century. After all, what woman could resist the chance to be portrayed in such a manner? The list of women who sat for such portraits reads like a Who's Who of society women: Eve Fairfax (marble; 1903), although the bust commissioned by her lover was eventually canceled when the two broke up; Mary Hunter (marble; 1904), renowned as a hostess in Edwardian London and good friend of the painter John Singer Sargent, who had painted her portrait in 1898; Lady Warwick (marble; 1908), lover of the Prince of Wales until 1898, after which she became a socialist concerned with issues such as equality for women and unemployment; and Kate Simpson (marble; 1904), who had met Rodin in 1897 and helped broaden his appeal in the United States.

In addition to busts of women, Rodin had numerous assignments for important men: the newspaper editor and publisher Joseph Pulitzer (bronze, marble; 1907); the celebrated composer and conductor Gustav Mahler (bronze, marble; 1909); Domingo Faustino Sarmiento (bronze monument; 1894–96), renowned author and president of Argentina from 1868 to 1874; the scientist and statesman Pierre-Eugène-Marcelin Berthelot (plaster; 1906); even Pope Benedict XV (bronze; 1915), to name just a few. Author George

Bernard Shaw, who had his bust done by Rodin in 1906, wrote in 1912 in an article in *The Nation*:

> Could Rodin be induced to undertake the work? On no other condition would I sit, because it was clear to me that Rodin was not only the greatest sculptor then living, but the greatest sculptor of his epoch, one of those extraordinary persons who, like Michelangelo, or Phidias, or Praxiteles, dominate whole ages as fashionable favorites dominate a single London season. I saw, therefore, that any man who, being a contemporary of Rodin, deliberately allowed his bust to be made by anyone else, must go down to posterity (if he went down at all) as a stupendous nincompoop.

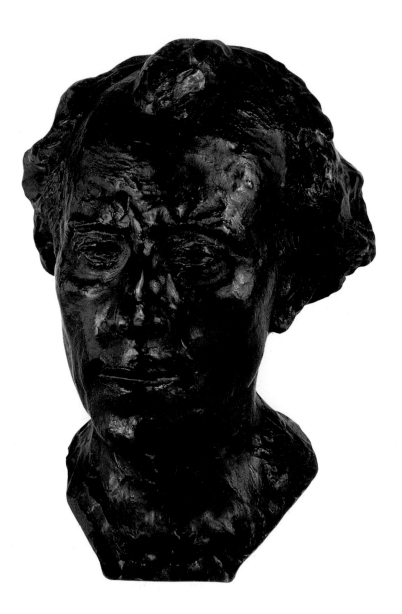

Not all Rodin's sitters were as pleased as Shaw, though. Both painter Pierre-Cécile Puvis de Chavannes and publisher Henri Rochefort believed the sculptor had made caricatures of them in their busts. The politician Georges Clemenceau reportedly denounced a number of heads Rodin sculpted of him in 1911, claiming that Rodin had made him look like a "Mongolian general" and even insisting that one shown at the Salon be called *Bust of an Unknown* rather than bear his name. The poet Countess Anna de Noailles was so displeased with her bust that she at first refused to accept it.

Rodin's philosophy of portrait making, especially with regard to men, was similar to his approach to monument construction, emphasizing the "moral and physical reality" of the sitter or subject rather than mere glorification, a method that sometimes led to displeasure on the part of his subjects. Many of his portrait busts of women, however, are less insightful, more surface portraits, though whether this was the result of a kind of respect for women or of the artist's lack of true interest in the sitter is subject to debate. There is no question, though, that Rodin was *capable* of producing drawings, busts, and figures of women that exude passion, hint at secrets, and probe the very being of the model.

Gustav Mahler

n.d., bronze. The Joseph H. Hirshhorn Bequest,
1981, Hirshhorn Museum and Sculpture Garden,
Smithsonian Institution, Washington, D.C.
Although Rodin was not a fan of the music of
the Austrian composer and conductor, he found
Mahler's features "remarkable," seeing in the man's
features a combination of Frederick the Great,
Benjamin Franklin, and Mozart. When this portrait
was carved in marble, it became known as *Mozart*.

Eve Fairfax

1905, marble. Musée Rodin, Paris.
Fairfax's lover Ernest William Beckett commissioned
this bust in 1901, then canceled it in 1904 when he
realized she would not marry him. Rodin continued
the project for his own enjoyment, having four
marbles cut until the bust was exactly as he wanted it.

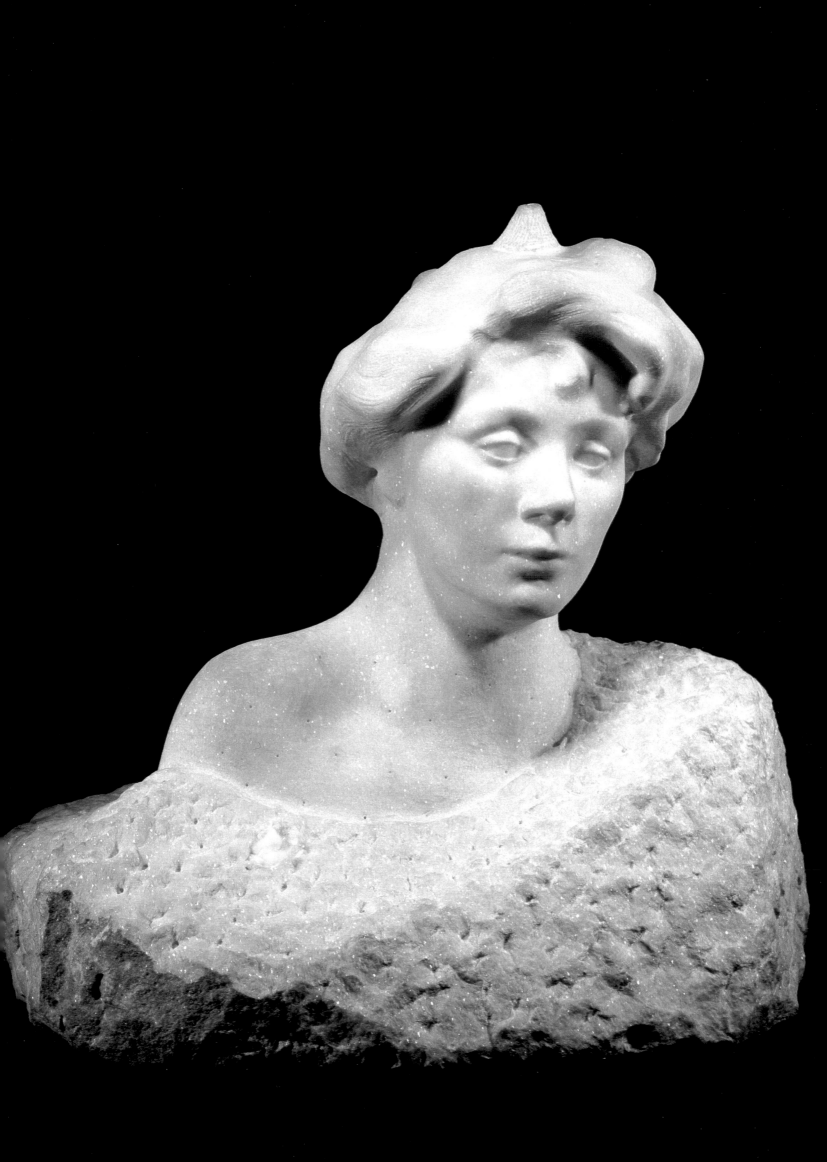

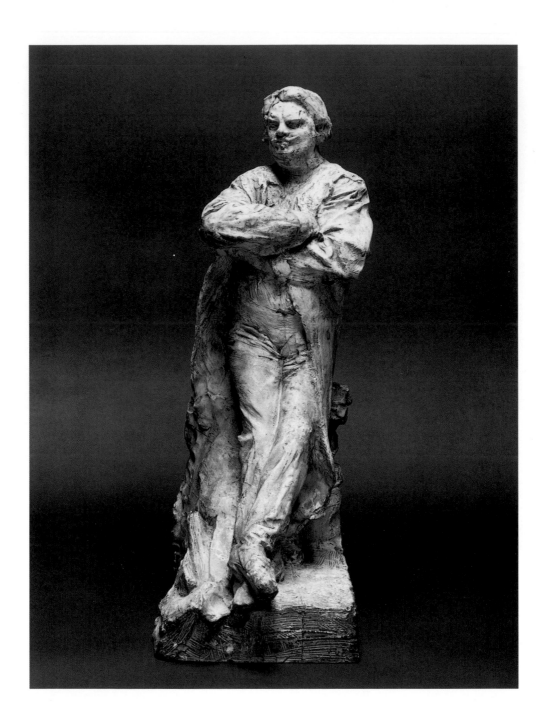

Balzac in a Frock Coat, Leaning Against a Pile of Books

1891–92, plaster. Gift of Jules E. Mastbaum, The Rodin Museum, Philadelphia.

Rodin did more than fifty studies for this monument.

This is one of the early versions, where the figure is clothed in a

contemporary frock coat. Rodin had commissioned Balzac's tailor to make an

outfit in the writer's size so he would have a better idea of the man's true stature.

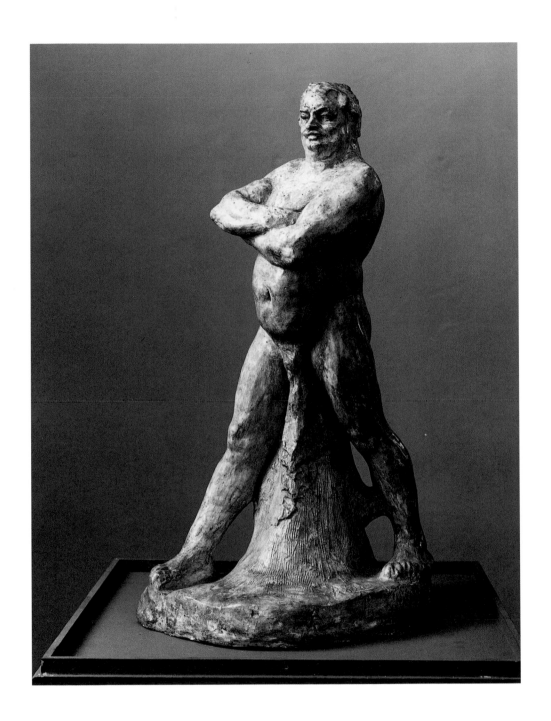

Naked Balzac

1892, plaster, painted with brown varnish. Gift of Mr. and Mrs. Shledon, M. Gordon,
Mr. Gerson Baker, and Mr. and Mrs. Norman Pertmutter, Philadelphia Museum of Art.
In attempting to portray the essence of Balzac, Rodin created
this naked and defiant figure, which faces the world head-on. Critics
were shocked by the huge belly and "deformed" proportions of the work.

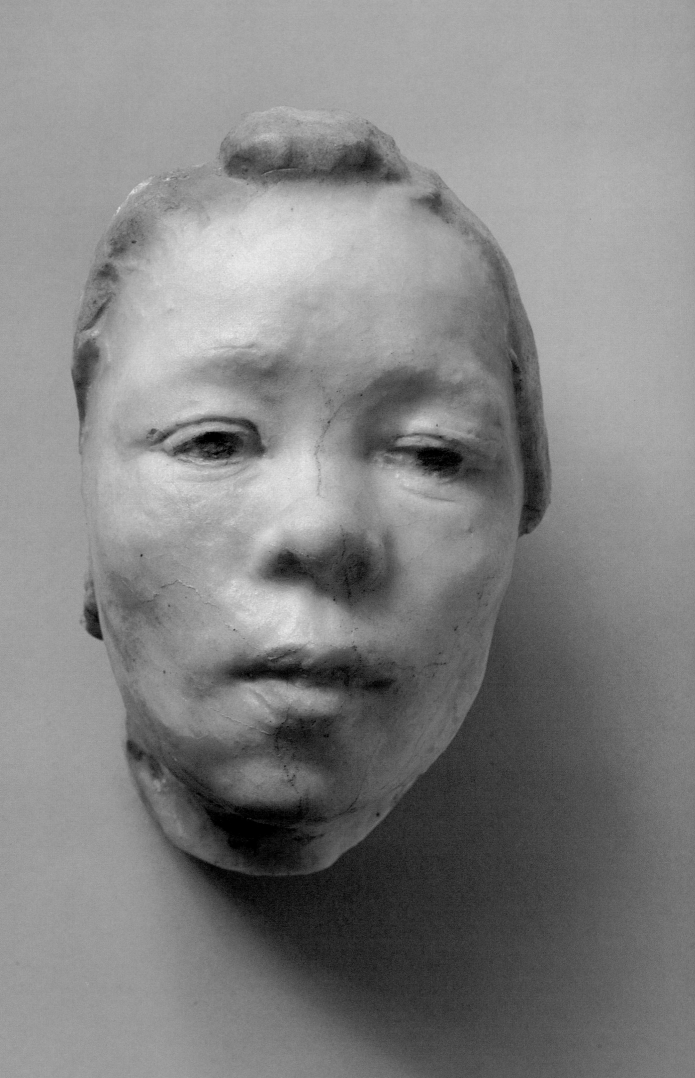

Hanako

c. 1908, pencil; 14¹/₄ x 8³/₄ in. (36.2 x 22.2 cm).
Rodin Museum, Philadelphia.
With Rose Beuret's help, Rodin persuaded
Hanako to pose in the nude for him. He
was impressed as much with the diminutive
actress's physical form as he was of her face,
commenting: "Her anatomy is quite
different from that of Europeans, but is
very beautiful, and has extraordinary power."

Mask of Hanako,
the Japanese Actress

1908 (executed 1911), pâte de verre. Gift of
Jules E. Mastbaum, The Rodin Museum, Philadelphia.
Rodin studied the Japanese actress Hanako
more intensely, and created more busts of her,
than any of his other female sitters. Hanako's
acting training allowed her to hold fierce, angry
poses for long periods of time. In this *pâte de
verre*, retouched by Rodin, he has succeeded in
his attempt to portray her in a "dying attitude."

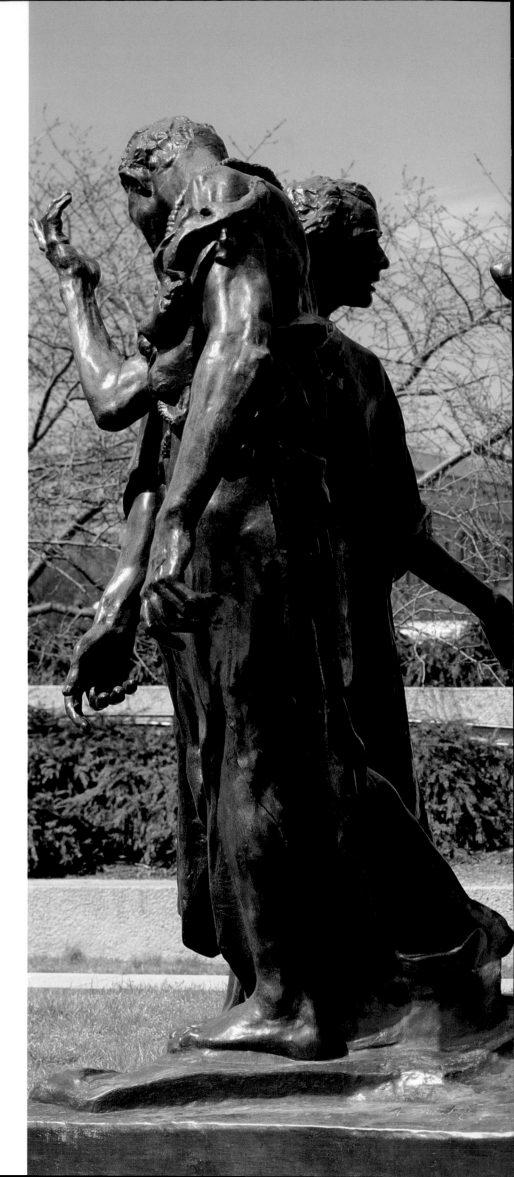

Auguste Rodin
MASTER OF SCULPTURE

The Burghers of Calais

*1884–95, bronze. Hirshhorn Museum
and Sculpture Garden, Smithsonian
Institution, Washington, D.C.*
The composition of this
piece was initially criticized for
its figures all being of the same
height, lacking the pyramidal
organization then common.
Although the individuals form a
group, each is alone with his
thoughts, debating one last time
the wisdom of his heroic action.

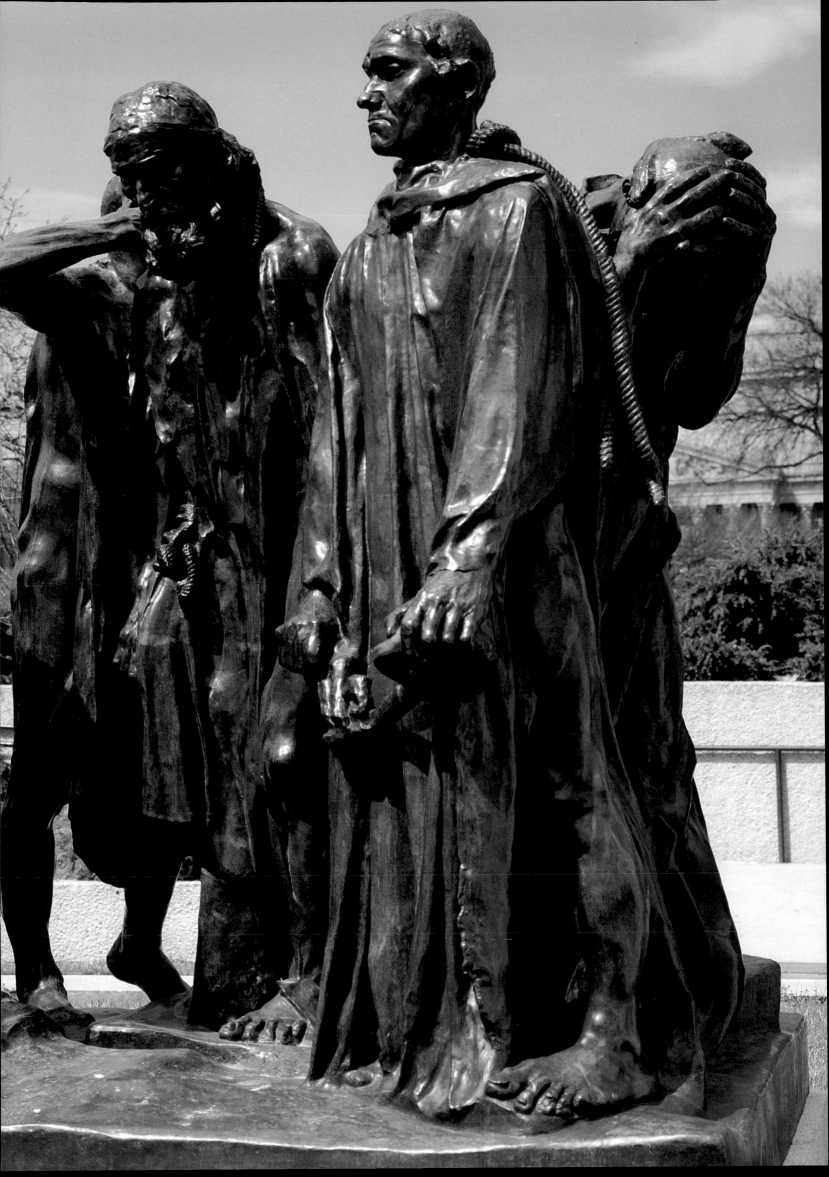

Séverine

PIERRE-AUGUSTE RENOIR; *c. 1885, pastel; 24½ x 20 in. (62.2 x 50.8 cm).*

National Gallery of Art, Washington, D.C.

Séverin (the pen name of feminist and socialist journalist Caroline Rémy)
was painted by the Impressionist Renoir almost ten years before Rodin executed her
bust. An intense expression differentiates this portrait from many of the painter's others
and shows signs of his transition to the more classical style he would adopt later in his career.

Project for the Monument to Eugène Carrière

1912, plaster. Gift of Jules E. Mastbaum, The Rodin Museum, Philadelphia.

Rodin greatly admired the French painter Carrière and
the feeling was returned. In 1912 Rodin submitted this plaster to
the committee that had asked him to make a monument to the painter,
who had died in 1906. Rodin appears to have modified a grouping that was
in existence since the 1890s, but did not develop the project beyond this proposal.

Samuel Stockton White, 3rd

c. 1900, photograph. Philadelphia Museum of Art Archives.
Samuel Stockton White, 3rd, originally from Philadelphia,
was studying at Cambridge University when he won the
Sandow Gold Medal for Development. A friend suggested
he offer himself as a model to Rodin, who, impressed with
the young athlete's physical development, accepted the offer.

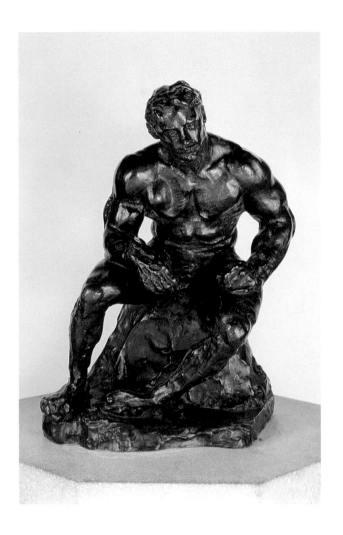

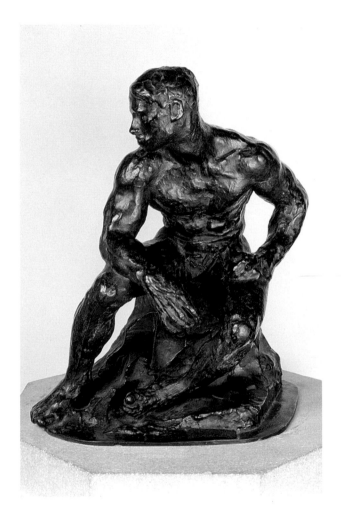

The Athlete—Sam White

1901–04, bronze. Samuel S. White, 3rd, and Vera
White Collection, Philadelphia Museum of Art.

When Rodin told White to choose a pose for a sculpture,
White sat in a style similar to that of *The Thinker*,
already a well-known piece by then. With the athlete's
more relaxed pose, this sculpture becomes more the concept
of a man at physical rest than in deep contemplation.

The Athlete

1901–1904, bronze. Gift of Jules E. Mastbaum,
The Rodin Museum, Philadelphia.

Although Rodin was known for exaggerating the musculature of his
earlier pieces, it was not necessary for this piece. The bulges, even
the outstanding veins, are a reproduction of the athlete's actual
body. The face, though, is less accurate, appearing almost incongru-
ously young and immature atop the well-developed, bulky body.

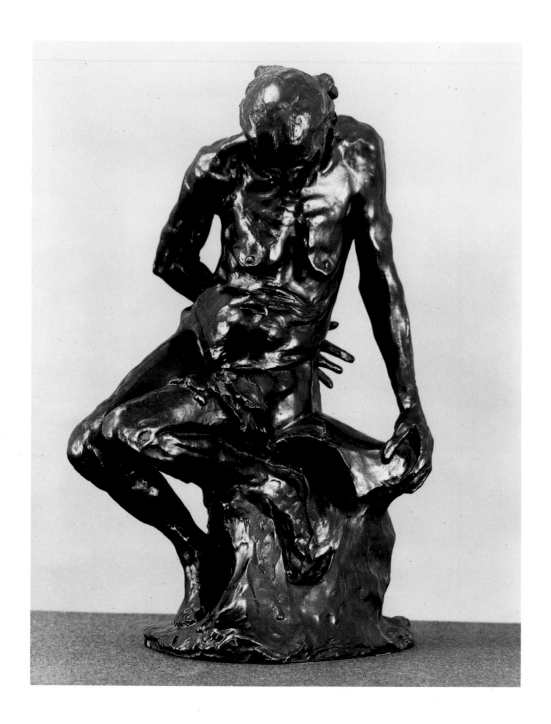

The Helmet-Maker's Wife (Front View)

1880–83, bronze. Gift of Jules E. Mastbaum, The Rodin Museum, Philadelphia.
The title of this work comes from a poem by the French poet François Villon
called "She Who Was Once the Helmet-Maker's Beautiful Wife." Presumably
Rodin created the figure first and then chose the title, as he did with all of his
other works. In the poem, an old courtesan laments the loss of her beauty.

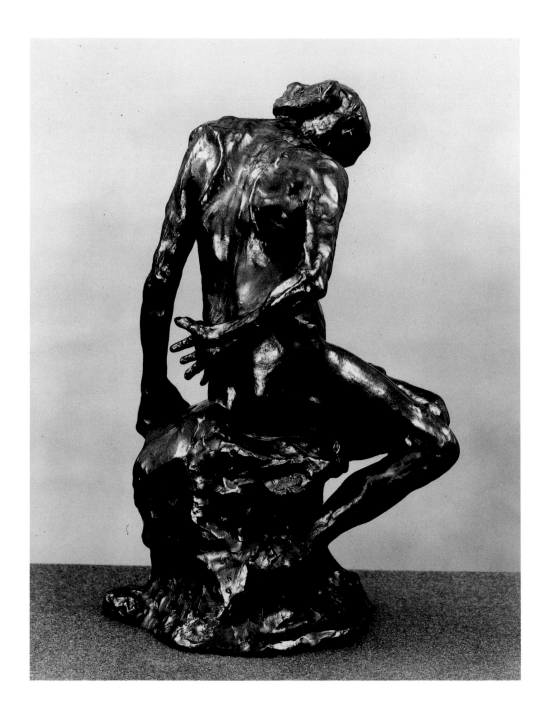

The Helmet-Maker's Wife (Back View)

1880–83, bronze. Gift of Jules E. Mastbaum, The Rodin Museum, Philadelphia.
This sculpture was the first time since his
Man With the Broken Nose that Rodin had tackled the concept
of "ugliness." He later told Paul Gsell: "What is commonly
called ugliness in nature can in art become full of great beauty."

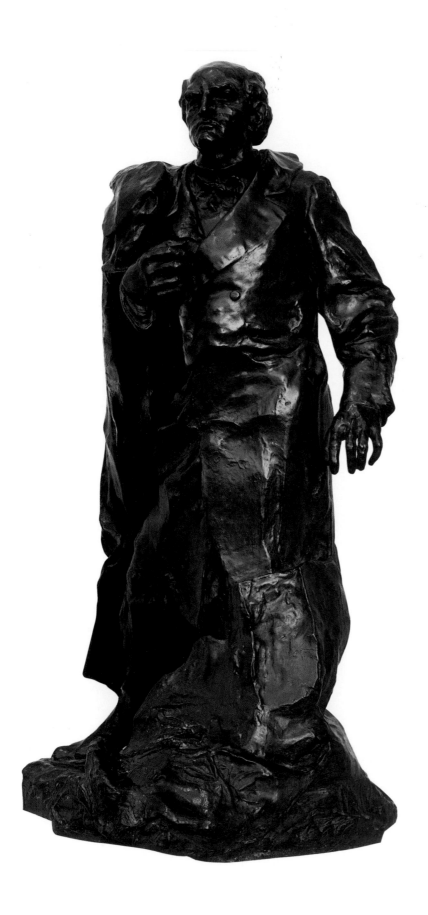

President Sarmiento

1894–96, bronze.
Gift of Jules E. Mastbaum,
The Rodin Museum, Philadelphia.
Rodin's reputation to this point
had spread enough that he was
asked to make a monument to
Argentina's first president,
Domingo Faustino Sarmiento.
Working from photographs,
Rodin strove for a dynamic,
intelligent, and compassionate
figure; in the end the monument,
especially the head, was criticized
for not bearing a physical
resemblance to the great man.

The Call to Arms

1879, bronze. Gift of Jules E. Mastbaum,
The Rodin Museum, Philadelphia.
Rodin submitted this piece in a
state-sponsored competition for a
monument to the defense of France
during the 1870 Franco-Prussian
War. The contorted collapsing
figure, with the Genius of War
hovering above him, was not
considered sufficiently heroic
and the monument did not even
garner an honorable mention.

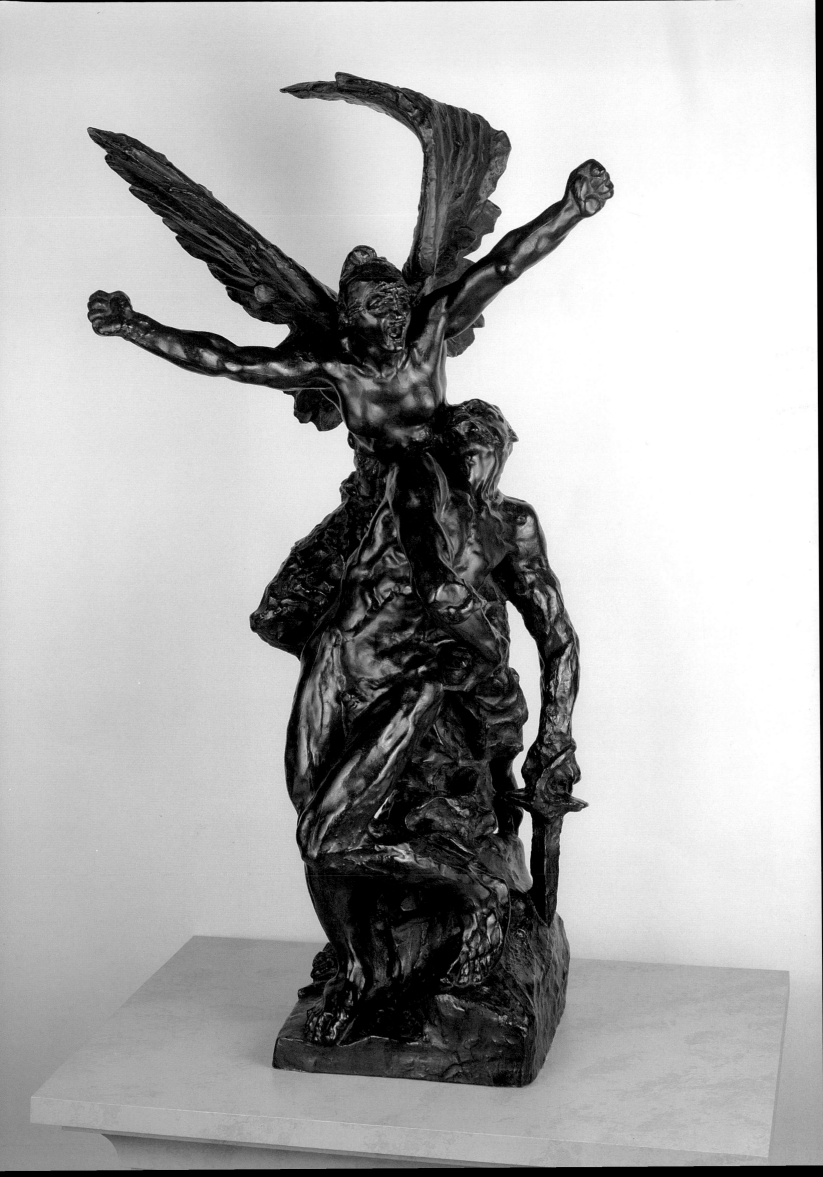

CHAPTER FOUR

RODIN'S PASSION

The ups and downs of Rodin's professional life were mirrored in his relationships with women. Like the artist's *Gates of Hell*, Rose Beuret, whom Rodin had met in 1864, remained a steady companion, the one constant in a changing palette of colorful affairs. Although Rodin and Rose had had a child and then moved in together in 1866, by the 1880s Rodin discovered that the simple country girl was not able to keep pace with the changes in his life. When he entered this period of increased social rounds and obligations, Rose did not accompany him, instead performing wifely duties at home, albeit unofficially.

Camille Claudel

By all accounts beautiful, intelligent, and gifted, Camille Claudel took her art as seriously as any male artist, in spite of her family's opposition. In late 1883, when she was nineteen years old, she was taking a class with other women from sculptor Alfred Boucher. When Boucher was unable to teach for a while, he prevailed upon his friend Rodin to take over the class. Rodin and Claudel were immediately attracted to each other and began an affair as mentally and emotionally strong as it was physically passionate.

For the next several years, the two were constant companions, although Rodin never officially stopped living with Rose Beuret. In 1885 Rodin offered Claudel the chance to work in his studio as an assistant, eventually giving her the important task of modeling most

Thought

1886, marble. Musée Rodin Museum, Paris.

Learning from Michelangelo's unfinished tombs of San Lorenzo, Rodin deliberately left the bottom of this piece unfinished in rough-hewn marble to provide a contrast to the finely honed face above, which is that of his lover Camille Claudel.

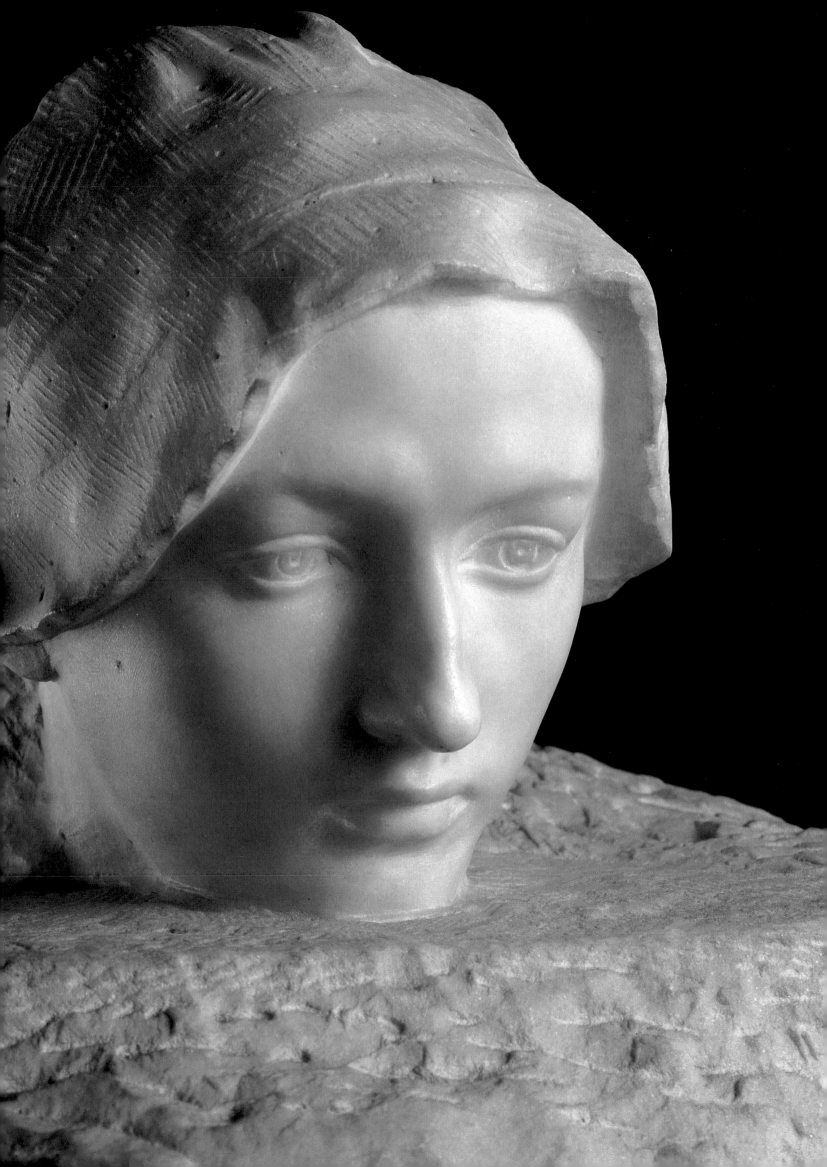

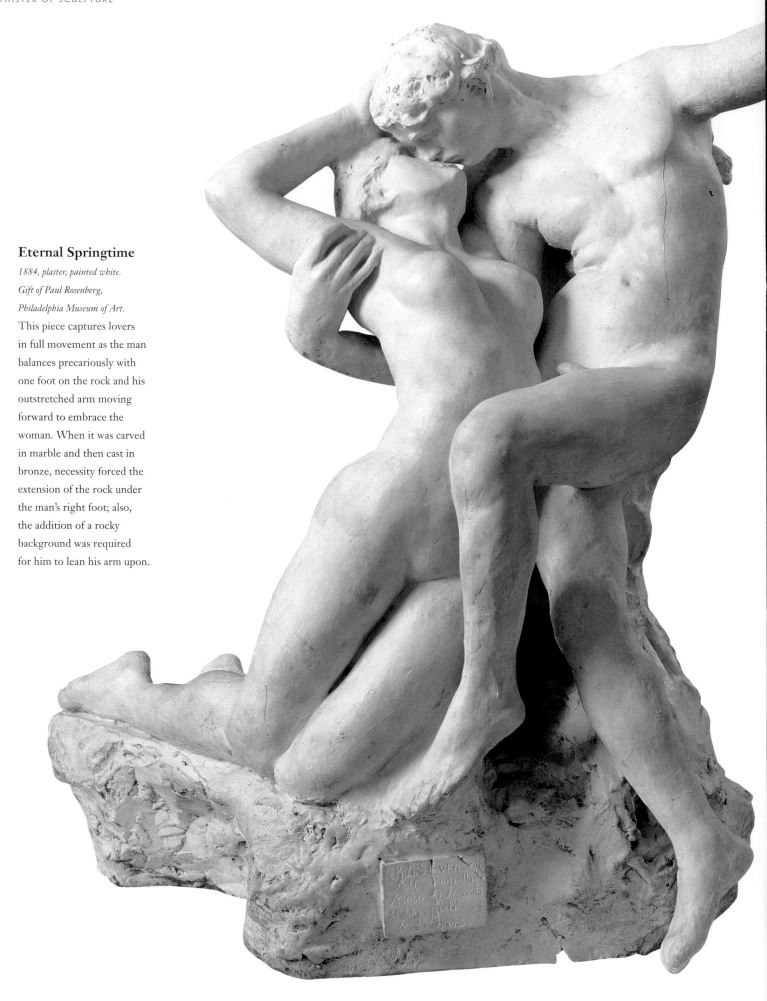

Eternal Springtime

1884, plaster, painted white.
Gift of Paul Rosenberg,
Philadelphia Museum of Art.
This piece captures lovers
in full movement as the man
balances precariously with
one foot on the rock and his
outstretched arm moving
forward to embrace the
woman. When it was carved
in marble and then cast in
bronze, necessity forced the
extension of the rock under
the man's right foot; also,
the addition of a rocky
background was required
for him to lean his arm upon.

of the hands and feet for his large figures. It is also thought that Claudel served as the model for a number of figures on *The Gates of Hell* as well as independent pieces, likely including *Aurora* and *France*. She was definitely the model, in 1886, for *Thought*.

During this period, Rodin was creating several groupings, such as *The Prodigal Son*, *Fugit Amor*, and *The Eternal Idol*, in which the figures arose out of a chunk of marble, providing a strong contrast between the finished pieces of the figures and the rough stone beneath. He used the same approach with Claudel's head in *Thought*, which he later modified for so many of his portrait busts of women. Anthony Ludovici, who spoke extensively with Rodin in 1906, described Rodin's effort in his 1926 book *Personal Reminiscences of Auguste Rodin:* "He said it was an experiment. He wished to see whether he could make the head so exuberantly alive, so thoroughly pulsating with life, that it imparted vitality even to the inert mass of marble beneath it."

Until 1888 Claudel lived with her parents and younger brother, future playwright and diplomat Paul Claudel—who were all unaware of the affair at the time. Then she moved to her own apartment to be closer to Rodin. Though she continued to assist Rodin, Claudel also created works of her own, including a bust of Rodin.

It is difficult to determine the exact extent of Claudel's influence on Rodin's work, but it is interesting to note that during the time they were together Rodin produced some of his most passionate sculptures of men and women together. Before the mid-1880s, most of Rodin's female figures had been lighthearted, almost frivolous girls, decorative pieces like *Young Girl with Roses on Her Hat*. From the mid-1880s to the mid-1890s, however, Rodin created numerous groupings of passionate lovers, including *The Kiss*, *Eternal Springtime*, *The Eternal Idol*, and *L'Emprise*.

Until this time, it was not unusual to show men and women locked in some sort of struggle—scenes of rape or abduction—not dissimilar from those of *Fugit Amor* or *I Am Beautiful*. Rodin, however, did not limit himself to such scenes and portrayed couples in a variety of poses. In *L'Emprise*, for example, the tables are turned and the woman, with a tail like a female satyr, is not fighting to free herself from the man but to hold onto him. The very name of the sculpture gives a clue to Rodin's intent. *L'Emprise* does not directly translate well into English but it encompasses the concept of domination over another. Alternative English names by which the sculpture is called include *Possession* and *The Succuba* (a demon that assumes female form to have intercourse with men while they sleep). At the Rodin Exposition in 1900, the description of this work in the catalogue read: ". . . the woman dominates almost the entire upper portion and ferociously grasps the man upon whom she has pounced as if he were her prey, and he no longer resists."

In the 1889 *Eternal Idol*, the woman no longer attacks but accepts as her due the worship of the man who kneels before her. The woman in *Eternal Springtime*, though in a submissive position, is clearly a willing participant in the embrace, while in *The Kiss* she is a full partner.

In 1892 Rodin executed another figure based on Claudel, called *Farewell*. The idyll the two had enjoyed was coming to an end and intense fights were becoming a way of life. In 1893 Rodin moved to the Villa des Brillants in Meudon and it became clear he was not going to leave Rose Beuret for Claudel, although he and Claudel stayed together for another five years. Even after their breakup, Rodin continued to try to help Claudel's career, honestly believing in her talent. "I have shown her where to find gold, but the gold she finds is truly her own," Rodin told Judith Cladel, whose book *Auguste Rodin: L'Oeuvre et l'homme* was published in 1908.

Claudel, however, soon came to resent Rodin's help: Rodin was becoming an international figure as she languished in the role of "Rodin's protégé." Claudel continued to work on her own sculptures but by 1905 her

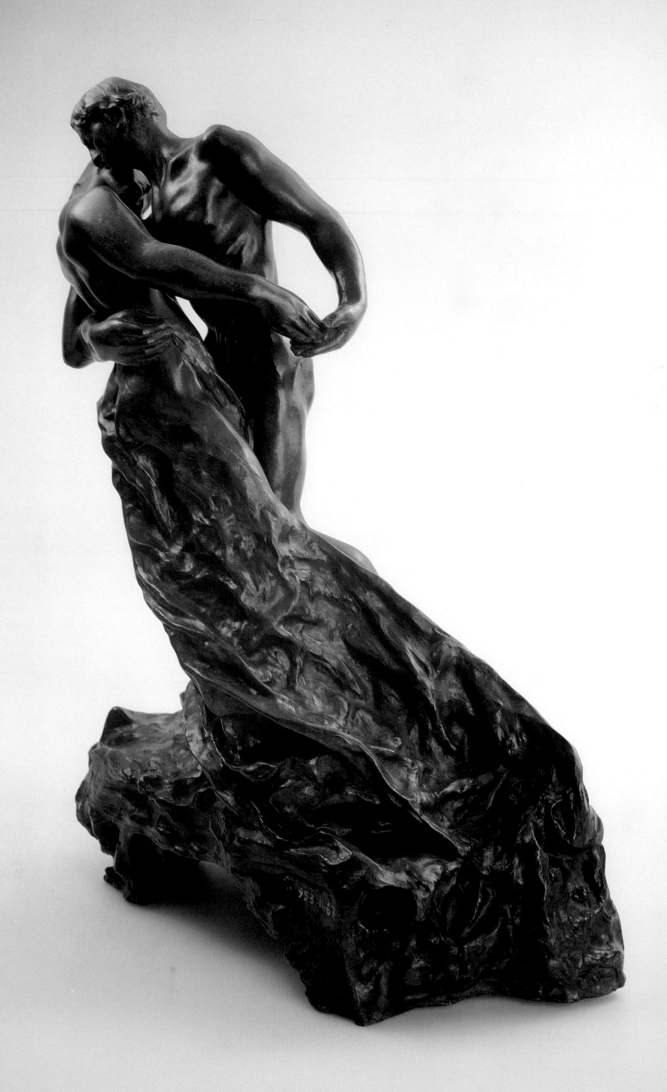

health—both physical and mental—was showing signs of severe deterioration. In 1913 her family had her confined to a mental institution, where she lived for thirty years until her death in 1943. Unfortunately, numerous works by Claudel were destroyed during the years of her illness, but those that survive have proven Rodin correct in his estimation of her talent.

Other Loves

While Rodin was exploring ideas of sexuality and the female body in his sculpture, he was also engaging in a study of women through his drawing. The Romantic movement had openly offered the possibility of sexual alternatives in the art of the nineteenth century. Like Gustave Courbet, Edgar Degas, and Toulouse-Lautrec, Rodin experienced a growing fascination with women's bodies.

From the 1880s onward, and especially after the turn of the century, Rodin executed thousands of drawings, most of women and often more frankly sexual than even his most explicit sculptures, focusing at times on rape, murder, lesbian and homosexual couples, groups of naked women, even women with the devil. These drawings, like his sculptures, were based on real models, whom he would ask to freely walk around his studio so he could draw them as they moved—embracing each other, throwing their legs up in the air, touching themselves. Unlike the society women who commissioned busts, most of these models remain anonymous.

The drawings became lightning fast studies of women in movement, and with time they became increasingly simplified. Rodin's method was straightforward: He never looked down at the paper on which he was drawing, focusing solely on the models in front of him rather than artistic technique. In his article "Notes on Auguste Rodin" in a 1931 edition of *Apollo*, the Symbolist poet and critic Arthur Symons wrote:

> In these astonishing drawings from the nude we see woman carried to a further point of simplicity than even Degas: woman the animal; woman, in a strange sense, the idol. . . . These are the drawings of a sculptor, notes for sculpture, and thus indicating form as the sculptor sees it, with more brevity, in simple outline, than the painter.

Symons is correct in stating that some of the drawings were the basis for sculpture, yet more often than

Illustration from *Le Jardin des Supplices*

1899, lithograph by Clot after a Rodin drawing;

12¾ x 9⅞ in. (32.4 x 25.1 cm). Philadelphia Museum of Art.

Critic and novelist Octave Mirbeau was turned down by numerous publishers before finding Ambroise Vollard, who published a small edition of his book. Both the novel and the drawings were considered too avant-garde and erotic by most publishers of the time. This illustration appears with the line: "And Clara's name, whispered from mouth to mouth, from bed to bed, and room to room, soon filled the flower-boat like a marvelous obscenity."

The Waltz

Camille Claudel

1905, bronze. Musée de Poitiers, Poitiers.

Originally Claudel's figures were completely naked, like many of Rodin's couples; the fine arts inspector Armand Dayot, however, told Rodin he could not purchase it for the state because of its sensuality. Claudel covered the lower half of the woman by the time she showed it in the 1893 Salon.

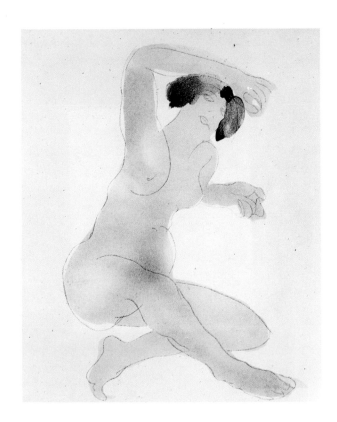

not they were never translated into sculpture by the artist. Sometimes of simple ink or pencil, sometimes finished off with a colorful wash, these drawings were made more for Rodin's pleasure than anything else.

As a natural outgrowth of his respect for movement, Rodin was especially fascinated with dancers. When the King of Cambodia came to Paris and Marseilles with Cambodian dancers, Rodin captured hundreds of the brightly costumed dancers in drawings overlaid with a wash. The famous dancer Isadora Duncan became a friend, as well as a model for sketches, and after defending the dancer Vaslav Nijinsky in the press against charges of indecency, Rodin did a series of drawings and a sculpture of Nijinsky dancing in the nude.

Although Rodin frequently exhibited his drawings at home to entertain visitors and even sold them as separate pieces of art, they were rarely on public exhibit; some notable exceptions include a Paris retrospective of his works in 1900 and in 1908 at the 291 Gallery in New York. Interestingly, though, the first important study of his work focused exclusively on his drawings: *Les Dessins d'Auguste Rodin*, published in 1897 with a preface by Octave Mirbeau. A few years later, in 1902, Rodin illustrated—simple contour sketches—Mirbeau's own *Le Jardin des Supplices*, an erotic avant-garde novel complete with themes that included torture and lesbian lovers. Other Rodin drawings showed up for mass consumption when he published simple line illustrations for an 1888 edition of Charles Baudelaire's *Les Fleurs du Mal*.

In his later years, Rodin was often accused of being obsessed with women and with sex. The British painter William Rothenstein recalls a conversation with Rodin in his 1931 book *Men and Memories*: "During a walk Rodin embarrassed me by remarking: 'People say I think too much about women.' I was

Two Women Embracing

c. 1885, pencil and watercolor, cut out and assembled from two sheets, gouache highlights. Musée Rodin, Paris.

There are more than seven thousand of Rodin's drawings at the Musée Rodin, many of which are women in erotic poses either alone or with each other. Here, Rodin concentrated on the connections between the two bodies rather than on the women's faces or the details of their individual bodies.

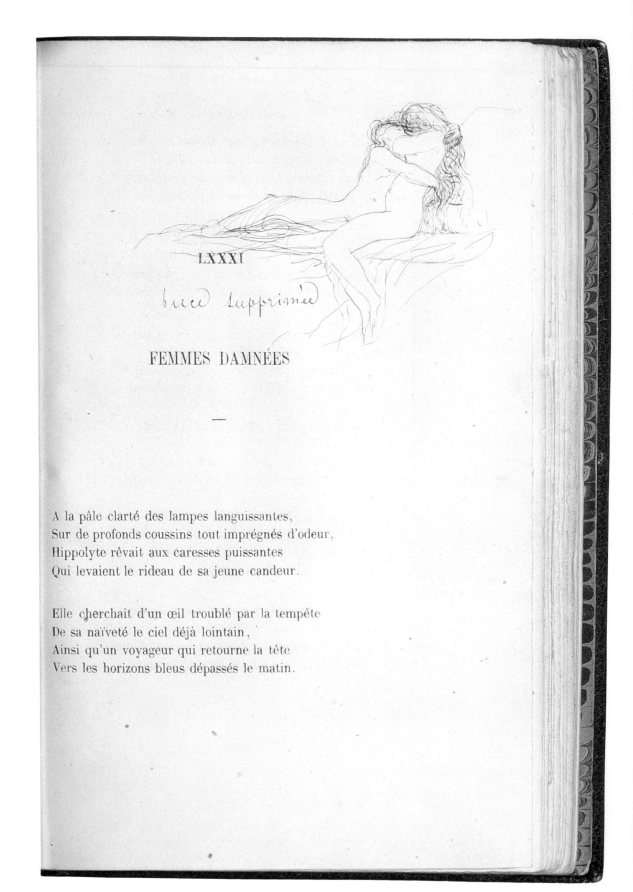

Damned Women

1886–88, illustration for Charles Baudelaire's "Femmes Damnées" from Les Fleurs du Mal, *Musée Rodin, Paris.*
Rodin did not draw his own sculpture of the same name to illustrate this poem, perhaps because it was easier to depict in a simple line drawing two women embracing side by side than to convey the sense of one woman atop of another.

LXXXI

bien supprimée

FEMMES DAMNÉES

—

A la pâle clarté des lampes languissantes,
Sur de profonds coussins tout imprégnés d'odeur,
Hippolyte rêvait aux caresses puissantes
Qui levaient le rideau de sa jeune candeur.

Elle cherchait d'un œil troublé par la tempête
De sa naïveté le ciel déjà lointain,
Ainsi qu'un voyageur qui retourne la tête
Vers les horizons bleus dépassés le matin.

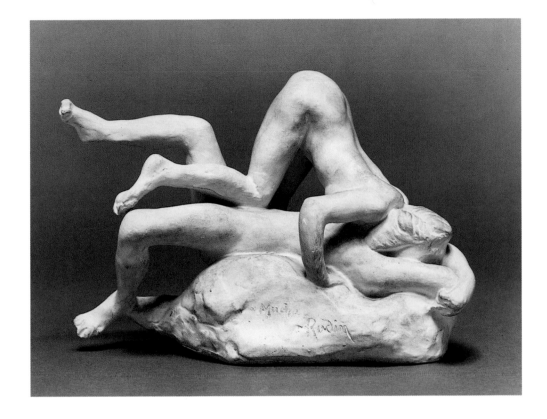

Damned Women

1885 (executed after 1911),
plaster. Gift of Jules E.
Mastbaum, The Rodin
Museum, Philadelphia.
Lesbian lovers became a
common theme for artists
of the late nineteenth
century. The models here
were two lesbian dancers
from the Opera whom
Edgar Degas had recom-
mended to Rodin. This
work was done during the
period when Rodin was
involved in *The Gates of Hell*;
the title is taken from a
Charles Baudelaire poem
from his *Les Fleurs du Mal*.

going to answer with the conventional sympathy, 'But how absurd!' when Rodin, after a moment's reflection, added, 'Yet, after all, what is there more important to think about?'"

In addition to the constant presence of Rose Beuret and revolving female models, Rodin had ongoing relationships with numerous women—some friends, some lovers. As his international reputation grew, his ever widening circle of friends came to include the German writer Helene von Nostitz-Hindenburg, whom he met in Italy and corresponded with regularly from 1901 to 1914; the Japanese actress Hanako, who performed in Paris in 1908 and who so fascinated him that he did a series of fifty-three studies of her face; the English diplomat's renowned spouse Lady Victoria Sackville and her daughter, writer Vita Sackville-West, who recorded many conversations with Rodin in her journal; and Judith Cladel, a faithful friend and eventual biographer.

Not of all his lovers are known, but more than two thousand love letters document the affair between Rodin and the English painter Gwen John. The two met in 1904 when she agreed to be a model for his

Muse, which was at first a part of the *Monument to Victor Hugo* and then a separate sculpture, and the letters continued for more than a decade.

Another woman who played an important role in the final years of Rodin's life was the Marquise Claire de Choiseul, who also sometimes chose to call herself Duchess, although apparently without any true claim. The daughter of a well-known New York lawyer, Choiseul first met Rodin through her husband, and she and Rodin began an affair in 1904. Letters and later accounts show that most of Rodin's friends believed she was a conniver, determined to charm her way into Rodin's will. Hundreds of drawings and small pieces disappeared from his home and studio during the time they were together before his friends were able to convince him that she was using him. He broke off with her at last in 1912 and went back to Rose Beuret, who was as yet waiting patiently at their home in Meudon.

By 1917, so many women and men were swarming around Rodin trying to get a piece of his estate that friends were able to convince him it was in his best interest to marry Rose. The two married on January 29, 1917; two weeks later Rose died of pneumonia.

Oceanids

Before 1910, bronze. Gift of Jules E. Mastbaum, The Rodin Museum, Philadelphia. Oceanids, the spirits of oceans, rivers, and other waters, were a popular subject of the early twentieth century. Unlike most of Rodin's figures, in which the muscles and forms are developed in detail, the fluid bodies of these women echo the motion of the water they rule over and merge with it.

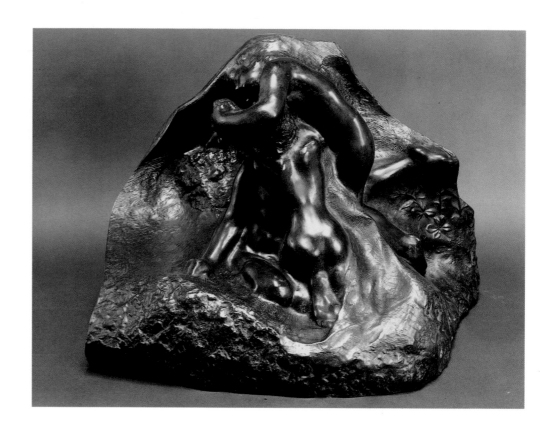

New Passions

As Rodin grew both older and better known, he was able to focus even more on ideas of personal interest. Long after he had stopped seriously working on *The Gates of Hell*, many of the themes he had first encountered with the doors continued to enchant him. Around 1910 he experienced a renewed interest in mythological themes which led him to produce a series of works that included *Oceanids*, *Entwined Women*, *Bacchantes*, *Bacchus in the Vat*, and others.

At the same time, there was an increase in themes taken from the Bible or related to concepts of good and evil: *Ecclesiastes*, *Bad Spirits*, and *The Good Spirit*, to name just a few. As always, Rodin continued to name his works after they had been created, sometimes with several variations, rather than first develop a concept and then create the work to fit a title.

Hands—which had already played such an important part in Rodin's major sculptures (the outstretched finger of *Adam* receiving life, the beckoning hand of Eustache de Saint-Pierre in *The Burghers of Calais*, the curled hand propping *The Thinker*'s chin)—took on a life of their own in his work from the end of the nine-

teenth century. Perhaps inspired by the medieval and Renaissance traditions that portray God as a hand emerging from the clouds, or perhaps developing the idea of artist as creator in imitation of God the creator, a twenty-year series of hands begins with *The Hand of God* in 1898 and ends with *Hand of Rodin Holding a Torso* in 1917, just three weeks before his death. In the former, God's hand is wrapped around the rock of earth and the first creation, while in the last a cast of Rodin's hand holds a small torso, possibly from *The Gates of Hell*.

Rodin also was able to indulge his passion for cathedrals, which had begun when he saw the Cathedral of Reims in 1876. Rodin's book *Cathedrals of France* was published in 1914, shortly before World War I and the bombing of his beloved Reims Cathedral.

Creating a Legacy

Perhaps even more important than the new works Rodin produced in the twentieth century was his desire—and ability—to ensure that he would be immortalized. Unlike many artists of the time, Rodin appreciated the value of photography, realizing that the

The Hand of God

1898, bronze. Gift of Jules E. Mastbaum, The Rodin Museum, Philadelphia.

God's hand here rises from the rock of earth to encompass both the rock and the first couple cradled in the rock. Rodin appreciated the comparison between God's creation and the works of an artist, telling Claudel: "When God created the world, it is of modeling He must have thought first of all."

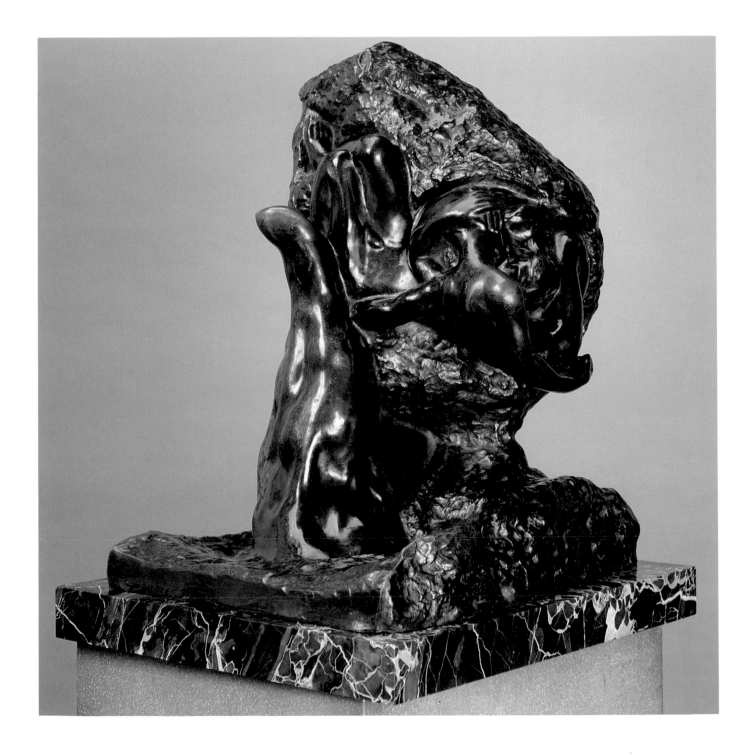

Hand of Rodin Holding a Torso

1917, plaster. Gift of Jules E. Mastbaum, The Rodin Museum, Philadelphia.
The amazingly lifelike hand here is actually a cast of Rodin's
own hand, taken by his assistant three weeks before Rodin's death.
With the insertion of the small torso, most likely one of the pieces
from *The Gates of Hell*, Rodin's hand holds his creation as both
God and the Devil held their creations in the artist's earlier works.

new medium could be seen not as competition but as a complement to existing art forms. He worked freely and happily with photographers who tried to capture the essence of his work, particularly the American photographer Edward Steichen, whom he greatly admired. In the 1908 book *Camera Work*, Rodin is quoted as saying: "I consider Steichen a very great artist and the leading, the greatest photographer of the time. Before him nothing conclusive had been achieved."

With help from his friends, Rodin also set about exhibiting his works as widely as possible. As early as 1899, Rodin traveled with his friend Judith Cladel throughout Belgium and Holland for the first important touring exhibition of his work. He also persuaded the French Municipal Council to approve his idea of a separate exhibition for his works within the context of the 1900 World's Fair in Paris. Required to finance his one-man show himself, Rodin borrowed money from clients who also happened to be bankers, trusting that admission fees and sales of works would more than cover the cost. In addition to 168 new and old pieces and works in progress of plaster, marble, and bronze, the exhibition featured drawings, photographs, and the first public viewing of *The Gates of Hell*.

Although Rodin was slightly disappointed in the money acquired from entrance fees, he was delighted with the commissions ordered from as far away as Hamburg, Budapest, and even Philadelphia. Rodin was so pleased with the results of the show that he reconstructed the Place d'Alma, where the exhibition had taken place, at his home in Meudon. His reputation now firmly established, Rodin continued to hold exhibitions in other countries, including Czechoslovakia, England, and the United States, and to receive commissions from countries as removed from France as Japan and Argentina.

In 1908, the poet Rainer Maria Rilke, previously Rodin's secretary and then his friend, told Rodin about rooms to rent at low rates at the Hôtel Biron. Rodin rented the entire ground floor to use as a studio, becoming neighbors in the process not only with Rilke but with other celebrated artists such as Jean Cocteau, Henri Matisse, and Isadora Duncan. By 1911, however, the building was scheduled to be demolished and all the tenants were asked to leave. At the suggestion of friends, most notably Judith Cladel and Gustave Coquiot, Rodin made an offer to the government. He suggested that he would donate all his works to the state if he could continue to keep his rooms at the Hôtel Biron, which would then be made over into a museum to his work. The proposal was finally voted through in 1916, the year he formally donated all his works to the French government. The Musée Rodin officially opened in the Hôtel Biron in 1918.

Perhaps Rodin had long suspected he would someday leave an indelible mark in the world of art because his donation to the Musée Rodin encompassed so much more than his sculpture. The terms of the bequest included not only all his art, but all his "writing, manuscripts, or printed works" as well. And although he had not specified it in the official donation, Rodin also had sketches, photographs, bills, letters from

friends, press clippings, even drafts of letters he had sent to others, which he had been collecting since the early days of *The Gates of Hell*.

In the meantime, Rodin had donated eighteen plaster casts to the Metropolitan Museum of Art in New York City. The idea of a collection there had been avidly supported both by the American financier and art collector Thomas F. Ryan, who contributed the necessary money, and Kate Simpson, a wealthy New York socialite. Simpson donated her own Rodin collection—consisting of twenty-eight sculptures, eight drawings, and three prints—to the National Gallery of Art in Washington, D.C., in 1942.

The second-largest collection of Rodin's works in the world, after the Musée Rodin in Paris, was opened in Philadelphia in 1929. Jules Mastbaum, a self-made philanthropist, had been collecting Rodin's works since 1923, choosing a range of pieces with an eye to eventually opening a museum to Rodin. His plan was to erect a Beaux-Arts building along Philadelphia's then new Parkway, which he would maintain as long as the city allowed him to keep and show the lauded sculptor's works there. Although Mastbaum died shortly before his dream could be realized, his wife continued his work, stipulating only that the city take and maintain the entire collection, which remains housed today in a secluded enclave along the busy Parkway.

"He Lives for Posterity"

In 1917, at the age of seventy-seven, Rodin could not have known the tributes that still awaited him. But he had done what he could. He had donated his works to the French government, guaranteeing a museum in his name; he had traveled the world showing and promoting his works; he had married Rose Beuret, assuring her security. Late on November 16, 1917, Rodin went into a coma, dying the next day of pneumonia. Rodin chose to be buried next to Rose Beuret at their house in Meudon, with *The Thinker* as their headstone.

During the days of Rodin's deepest despair, when he was struggling to enter the Grande Ecole and prove himself, his father had written him a letter of encouragement. Nearly sixty years later, his words had proved to be prophetic: "The day will come when one can say of you as of truly great men—the artist Auguste Rodin is dead, but he lives for posterity, for the future."

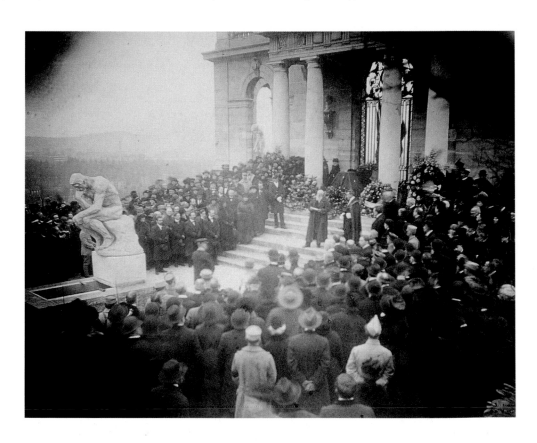

Rodin's Funeral at Meudon, November 24, 1917
UNKNOWN PHOTOGRAPHER *1917, photograph. Musée Rodin, Paris.*
It is likely Rodin would have received a state funeral if the French nation had not then been preparing for its entry into World War I. The sculptor's funeral took place at his home garden in Meudon, with friends and dignitaries in attendance. Rodin chose to be buried next to Rose Beuret, by then Madame Rodin, with *The Thinker* as their tombstone.

Possession (L'Emprise)

c. 1888, plaster. Gift of Jules E. Mastbaum,
The Rodin Museum, Philadelphia.
Rodin's sculptures often explored
the complex relationships between
men and women, especially those
of the period when he was working
on *The Gates of Hell*. Here, the
well-defined muscles of the
woman's legs and arms show
her struggle to hold onto the
man as he fights to free himself.

Camille Claudel

1884, bronze. Musée Rodin, Paris.
During Rodin's tumultuous affair with the artist
Camille Claudel, he immortalized her in several
busts and numerous works for *The Gates of Hell*.
Although well into work on *The Gates* by the time
of this piece, Rodin returned to his earlier style
of using blank eyes and smooth surfaces to give
Claudel the look of a young Roman nobleman.

Farewell

1892, plaster. Musée Rodin, Paris.
The last piece Rodin made of
Claudel presages the end of their
affair. Here, her head is not as
clearly delineated from the rock
as it is in *Thought*; rather the head,
hair, and fingers delicately touching
her lips gradually emerge in a
swirl from the rough marble below,
replacing the rational thought of
the first piece with intense emotion.

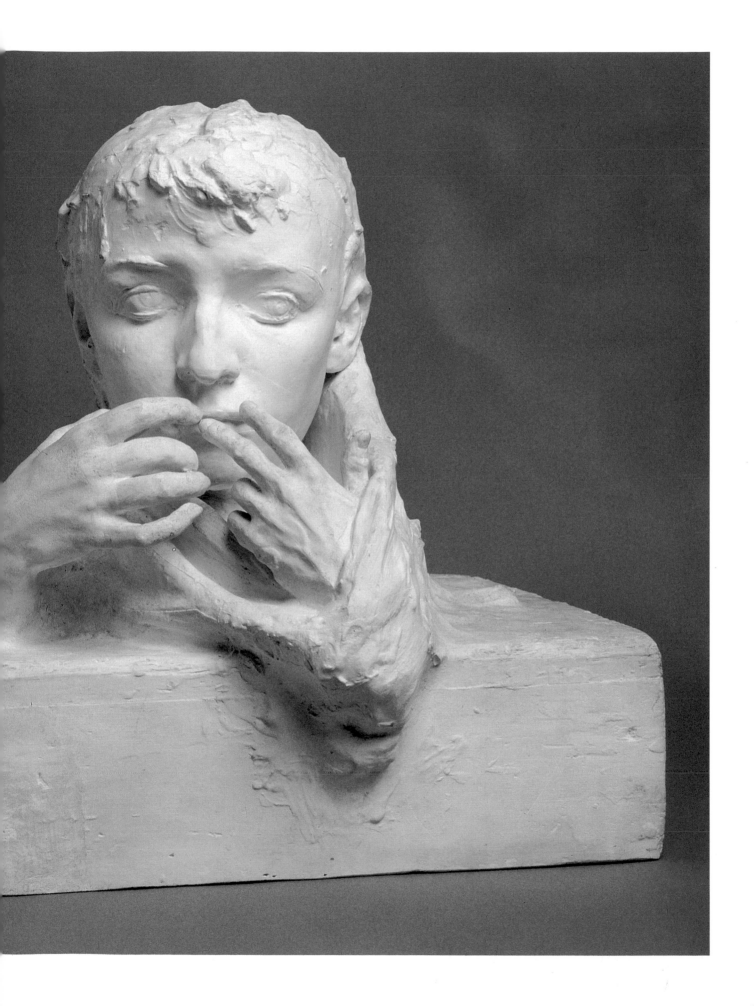

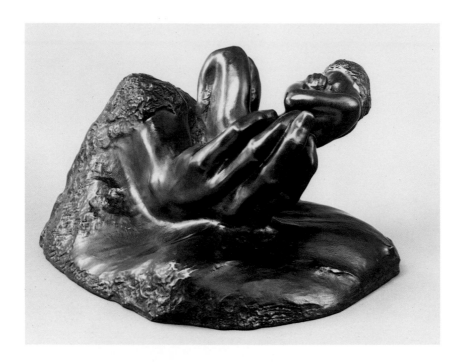

The Hand of the Devil Holding Woman

1902, bronze. Gift of Jules E. Mastbaum, The Rodin Museum, Philadelphia.
In counterpoint to *The Hand of God*, in which God's hand
lovingly holds the first couple, here the Devil's hand caresses
a lone female figure. It was not uncommon to associate
woman with evil—specifically, equating Eve's sin with the
fall of humanity—at the beginning of the twentieth century.

Çacountala

CAMILLE CLAUDEL; *1905, marble. Musée Rodin, Paris.*
Claudel based her sculpture on an epic poem by the
fifth-century Indian Kalidasa, a work little known in
France at the time. The sculpture shows the king's return
after many years of being under a spell. It was called
Vertumnus and Pomona when executed in marble in 1905.

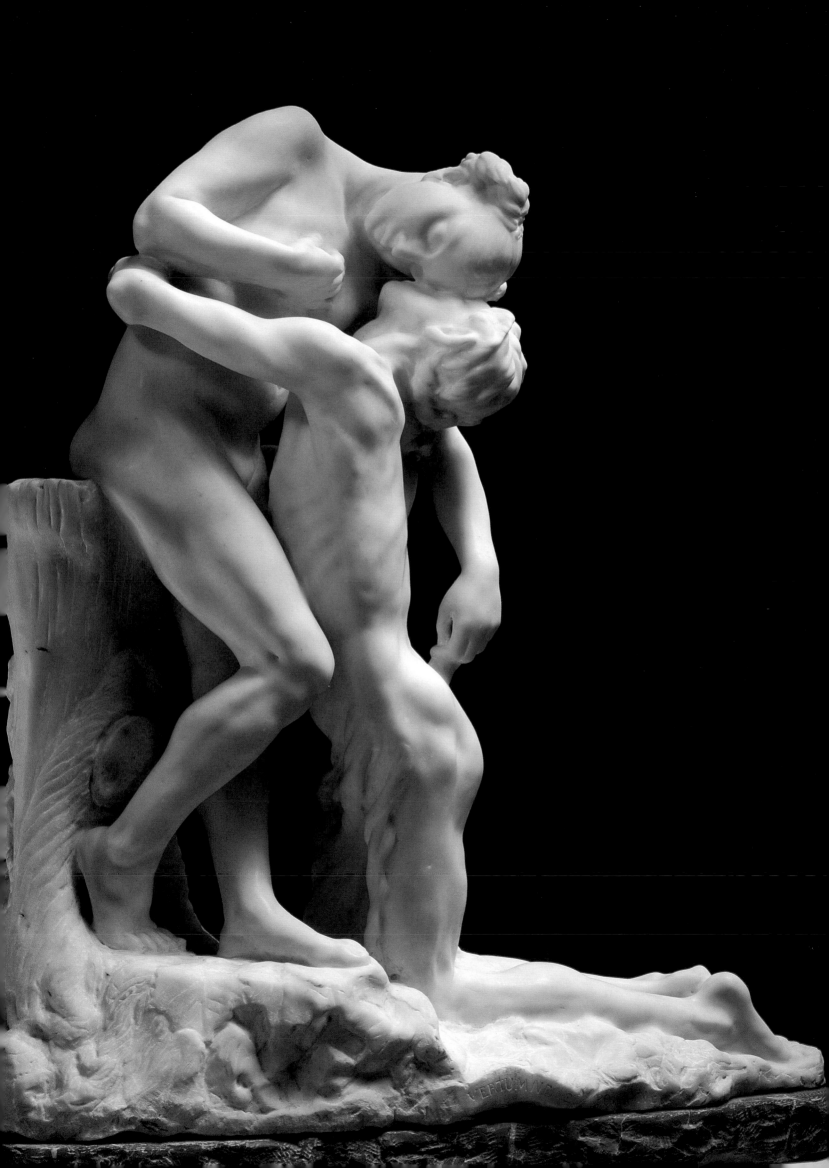

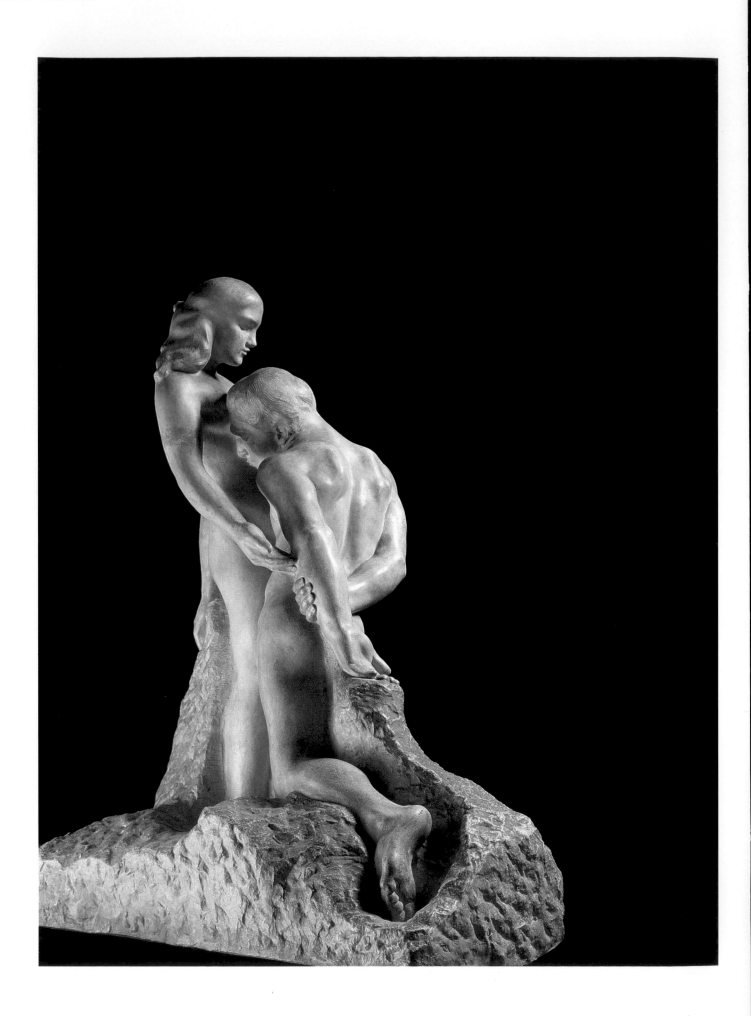

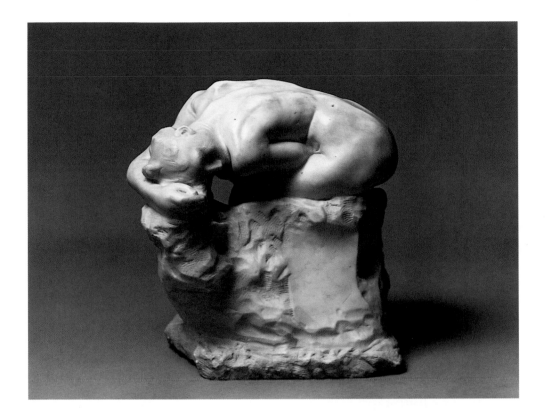

Andromeda

1885, marble. Gift of Jules E. Mastbaum, The Rodin Museum, Philadelphia.
One of five Rodin pieces exhibited by Sarah Tyson Hallowell at the 1893 World's
Columbian Exposition in Chicago, *Andromeda* was deemed too risqué for an
American audience and removed from the public exhibit hall, along with the
sculptor's *Cupid and Psyche* and *Sphinx*. Unlike most portraits of Andromeda, who
is typically portrayed at the moment of release, via Perseus, from the rock, Rodin
shows her still chained to the rock. Bent over in despair, her hair merges with the
rock so that it is difficult to see where the rock ends and the person begins.

The Eternal Idol

1889, plaster. Musée Rodin, Paris.
Rodin and Camille Claudel exerted a mutual influence
apparent on each other's work. This pairing is similar in
composition to Claudel's *Çacountala*, shown the year before
at the Salon. In Claudel's piece, though, the woman moves
in to welcome the embrace of her worshipping lover;
Rodin's woman coolly accepts the worship as her due.

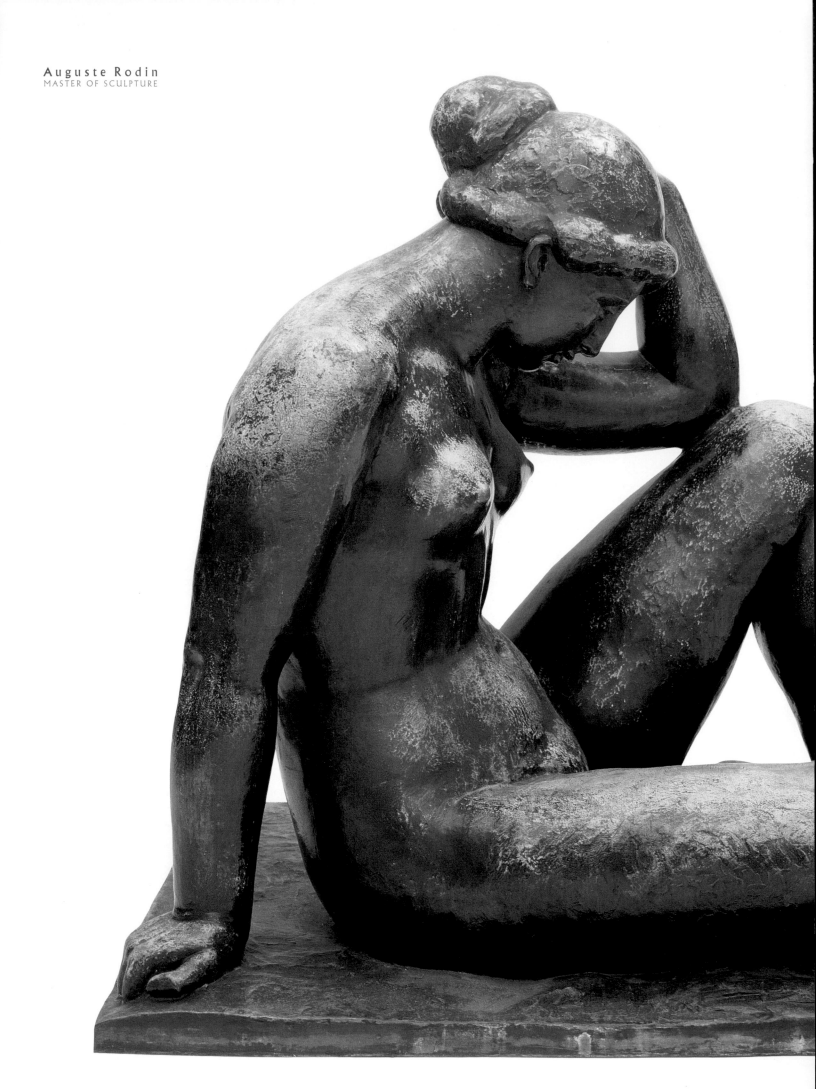

The Mediterranean

ARISTIDE MAILLOL; *1902–05 (cast 1951–53), bronze.*
Gift of Stephen L. Clark. The Museum of Modern Art, New York.
Although Maillol and Rodin praised each other's work
in public, the two artists had many differences in style.
The calm and monumental figures here possess a sense
of classical dignity, very unlike the active passion so
apparent in Rodin's sculpture. Still, Maillol later admitted
he "understood what was interesting" about Rodin's art.

Psyche

1886, marble. Musée Rodin, Paris.
Rodin crafted his *Psyche*—the
Greek goddess who is the per-
sonification of the human soul—
as more the essence of a female
figure than a fully developed
woman. Merging with the rock
behind her, she is incomplete,
still in the process of becoming.

Seated Cambodian Dancer

1906, pencil and gouache; 12⅜ x 7¾ in. (31.3 x 19.8 cm). Musée Rodin, Paris.
When the King of Cambodia came to France, Rodin was
fascinated by the dancers who accompanied him. Rodin
drew the dancers at rest and in mid-dance. After drawing
them in pencil, he would cover them in a colorful wash.

Nude Woman (Galatea)

1889, bronze. Gift of Jules E. Mastbaum, The Rodin Museum, Philadelphia.
A study for Rodin's *Pygmalion and Galatea*, this Galatea is shown as she
hesitantly comes to life. Created as an ivory statue by the artist Pygmalion,
Galatea is brought to life by the goddess Venus. In the grouping of the
two together, Pygmalion looks upon his work with admiration and lust.

Small Venus Victorious, with Base Showing the Judgment of Paris

PIERRE-AUGUSTE RENOIR;
*1913, bronze. Gift of Joseph H. Hirshhorn,
Hirshhorn Museum and Sculpture Garden,
Smithsonian Institution, Washington, D.C.*
Made years after Rodin's *Galatea*,
Renoir's *Venus* holds a noticeably
similar position. In the painting,
however, the body of the goddess
of beauty and love faces forward
as she proudly presents herself to
the world while the man-made
creation, Galatea, turns both her
body and head away from the viewer,
as if either ashamed or hesitating.

The Cathedral

1910, bronze. Gift of Jules E. Mastbaum, The Rodin Museum, Philadelphia.
Rodin merged his love of hands with his passion for cathedrals to create
this unusual piece. The combination of the two right hands, with fingers
touching, brings to mind a Gothic arch, the inspiration for the title.